Reinventing Screen Printing

Reinventing Screen Printing

Inspirational Pieces by Contemporary Practitioners

Caspar Williamson

First published in Great Britain
in 2011 by A&C Black, an imprint
of Bloomsbury Publishing Plc.
36 Soho Square
London W1D 3QY
www.acblack.com

ISBN 978-1-4081-5147-1

Copyright © RotoVision SA 2011

CIP Catalogue records for this book are
available from the British Library and
the US Library of Congress.

Caspar Williamson has asserted his
right under the Copyright, Design and
Patents Act 1988 to be identified as the
author of this work.

Typeset in 7.75 on 11pt Archer
Book design by Stuart Tolley
at Transmission

Cover design: Stuart Tolley
at Transmission
Art direction: Emily Portnoi
Photography for "Screenprinting
in Practice": Ivan Jones
Commissioning editor: Isheeta Mustafi
Copy editor: Amanda Crook

Printed and bound in China

This book is produced using paper that
is made from wood grown in managed,
sustainable forests. It is natural,
renewable and recyclable. The logging
and manufacturing processes conform
to the environmental regulations of the
country of origin.

Contents

Foreword

I have the best job in the world. I am a printmaker and a designer. Not only do I produce my own work alongside my business partner and best friend, Tad Carpenter, but I also get to work with some of today's most popular and talented visual artists from all over the country. Collectively, Tad and I make up Vahalla Studios – a full-service design, screenprinting and letterpress studio in Kansas City, USA. Over the past 10 years the world of printmaking and design has undergone a huge shift towards the boutique and hand-made goods that Vahalla so proudly produces.

Throughout my young career, and during my time at the University of Kansas (2001–04), I heard more than once that print was a dying art. Those words filled me with confusion and made me ask myself many questions. This statement was thrown around so loosely that it seemed ridiculous to pursue a career in printmaking. Computers were the wave of the future. Why would one choose to pursue a dying art? But, more importantly, why were people saying that print would become obsolete?

Over the past 30 years the computer, and more recently the internet, has been at the forefront of how people interpret their world and obtain information. During this time, long forgotten were the lengthy print methods of both screenprinting and letterpress. The computer sped things up to such immediacy that we lost the value that exists in the smell of ink, the touch of paper and the sweat of the labour required to produce it. Who had the time to separate their art into layers, or hand set typography from wooden blocks – let alone cut rubylith into film separations? All you had to do was lay out a design on a computer and press 'print'. Out came your design and you could move on to the next one. The computer was an ingenious invention and it was going to change things forever!

The computer has indeed changed things forever. What it has not done is eliminate the world of print. If anything it has achieved just the opposite. The limits of the computer exposed us to what was missing. It has made us long for luscious papers, full bleeds, die cuts, scores and floods of colour.

I belong to the first generation to grow up with computers involved in their everyday life. From Atari to PlayStation, IBM to Macintosh, and mobile phones to iPads, we have been overwhelmed with new ways of obtaining information. But with every new technology there lies an uncertain amount of time needed to adjust. As we have now had some time to digest both the strengths and weaknesses of the computer we have only begun to realise its full potential. The artists and designers of today that I am so blessed to consider my colleagues have started to use the computer to enhance the way that they produce art.

What is so wonderful about this approach to art and design today is that we have realised all the beautiful methods that existed before us, and have figured out how to use the computer to aid us in making these processes more productive and less limiting. Plates can be laid out in programs such as Adobe Illustrator. Screens can be separated in Photoshop. Adjustments, refinements and mock-ups have become limitless and so easy to compose that the print methods of old have become revitalised with a vigour and life that did not exist before.

Now that I have had a chance to explain how we got to where we are today, I am pleased to say that I am truly honoured to have been asked to write a foreword for this book. Screenprinting is an age-old practice that has changed my life in more ways than one. I would not be where or who I am today if it were not for this most basic of printing methods. It is a beautifully simple process that people of any skill level can enjoy. Tedious and strenuous at times, but always rewarding, even if your print does not turn out the way you intended.

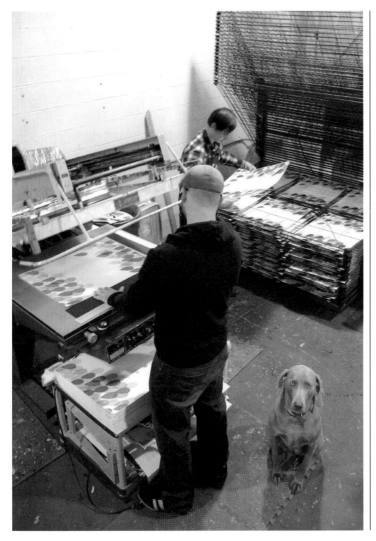

The craft of screenprinting can take a lifetime to master and spans many levels of production. From the simplest one-colour, hand-pulled art print to a run of 10,000 T-shirts on an eight-colour automated press, the screenprint is experiencing an exciting resurgence and will be with us for many years to come!

Dan Padavic
Vahalla Studios, 2010

Dan Padavic, Evan Davies and Kona, Dan's dog, running the press. Photo by Andy Erdrich

A Short History

Screenprinting is in the throes of a revival, with creatives of all kinds rediscovering the artistic opportunities this most traditional printing technique has to offer. The screenprinted look taps into the popularity of the hand-made aesthetic, placing this discipline in a modern context and allowing artists and designers to create beautiful examples of contemporary work.

Early screenprinting

Screenprinting was first documented during China's Song Dynasty (960–1279). Printing using wooden blocks meant that books – a vital source of education – could be reproduced relatively quickly. Japan and other Asian countries also advanced printing around this time, using block printing together with paints and basic stencils.

Silk screens

In the eighteenth century a printing process that used silk held between two pieces of strong, stencil-cut, waterproof paper was developed in Japan and China. The paper was glued together, leaving the silk exposed to allow the paint to flow through. These are believed to be the first examples of 'silk screens'.

With the boom in the silk trade, silk-screen printing was introduced to Western Europe during the late 1700s. Silk mesh was increasingly available from the East, leading to the larger acceptance and use of silk-screen printing in Europe. In the nineteenth century the process was developed, particularly in France, for stencilling patterns onto fabric and objects such as shoes. The printing process itself, however, remained simple and basic.

Developing methods

At the turn of the twentieth century Samuel Simon, a sign painter working in Manchester, UK, realised that by applying the silk-screen technique to his daily work he could revolutionise the business. Simon began perfecting the basic wooden-framed method, developing an emulsion that could be painted onto the silk stretched over the frame to block out the images or stencils,

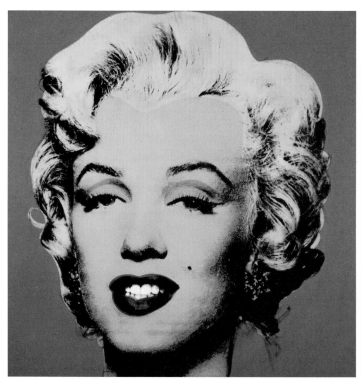

Andy Warhol,
Turquoise Marilyn, *1962*

and using a stiff brush to force inks through the screen. This allowed him to print signs continuously, removing the labour-intensive process of painting each one by hand. The process was soon described as silk-screening, and in 1907 Simon was awarded a patent for what became the first screenprinting process.

Simon began travelling around the UK, teaching sign makers about the benefits of and potential profits to be made using this new form of printing. It wasn't long before Simon's method spread to other countries, and silk-screened images were soon appearing in towns and cities across Europe and the rest of the world.

The photo-emulsion process

Early in the 1910s Roy Beck, Charles Peter and Edward Owens began experimenting with photoreactive chemicals to advance the intricacy of screenprinted images through the emulsions they used on the screens. This revolutionised commercial screenprinting by introducing photo-imaged stencils to the still-burgeoning industry.

This process, however, was not unanimously well received; many in the industry were concerned about the toxic nature of the chemicals used to develop the emulsion. Eventually safer emulsion chemicals were introduced for making photoreactive stencils, creating a screenprinting method that could be used safely in the workplace.

Growing popularity

Screenprinting soon began to attract an increasing number of artists worldwide. In 1914 an American printmaker, John Pilsworth of San Francisco, took out a patent for a multicolour printing device. Following Simon's basic method, along with the photo-emulsion process of Beck, Peter and Owens, Pilsworth began combining several stencils. Using a number of different screens and multiple colours allowed him to produce vibrant, multicoloured imagery.

Pilsworth's process contributed greatly to the poster revolution of World War I, which produced such iconic imagery as the silk-screened image of Uncle Sam on J. M. Flagg's 1917 recruitment poster.

This period also saw the development of the squeegee – a flat, rigid board with a flexible rubber edge – which was designed to force ink through the screen. Using the squeegee made printing more efficient and its results more uniform than those attainable using the stiff brushes of Simon's method.

Art versus industry

As screenprinting became more popular and more often used in industry, one group of artists sought to differentiate between its artistic and its industrial use. In the 1930s they formed the National Serigraphic Society (NSS) in the USA, to exhibit and promote screenprinting throughout the world.

Carl Zigrosser, curator of the Philadelphia Museum of Art and founding member of the NSS, coined the word 'serigraph' from the Latin word for silk, *seri*, and the Greek word for 'to write', *graphos*. The term serigraph was used in the hope that it would distinguish the 'creative art' silk-screen print from its commercial brethren.

World War II

By World War II Hollywood's film industry had woken up to the benefits of this new and efficient image-printing method, and thousands of movie posters were screenprinted and hung in cinemas across America every week.

Screenprinting was also used for the military's benefit. Servicemen's garments, such as shirts screenprinted with the words 'U.S. Army Property', were widely distributed to troops during World War II. Planes, tanks and other items of equipment were also printed with

identification numbers, and regiment branding was applied using screens, stencils and squeegees.

By the end of World War II the silk used for parachutes was being replaced with the new synthetic, polyester. This was much cheaper to make, far more reliable, and stronger than silk. It was also reuseable and produced infinitely more durable screens. This is why the term 'silk screen' is no longer commonly used, as the screen is made from terylene, nylon or polyester rather than the more traditional silk.

The art world

Andy Warhol is generally credited with popularising screenprinting through the Pop Art movement of the 1960s. However, almost a decade before Warhol a printer named Luitpold Domberger paved the way for the medium's growing artistic reputation.

Domberger offered the use of his print studio in Stuttgart, Germany, to prominent artists associated with the Op Art movement. The vision of artists such as Josef Albers and Victor Vasarely, combined with Domberger's pursuit of perfection as a screenprinter, created superior, finely executed serigraphs, which were highly sought by art galleries and collectors around the world. Their work, together with the experimental output of artists such as Jackson Pollock, helped to keep the screenprint medium at the forefront of printmaking.

In the 1960s many artists found the medium's large scale and solid bright colours perfect for the ideas of the time. Andy Warhol and Roy Lichtenstein in the USA, and Eduardo Paolozzi and Joe Tilson in the UK, familiarised the technique. Warhol is particularly identified with his 1962 depictions of actress Marilyn Monroe.

Modern screenprinting

Screenprinting is now a sophisticated process. Computers can produce very fine, detailed artwork, and exposure units can transfer this detail to the screen. Improved machinery can print elaborate and complex designs on almost any surface: paper, card, wood, glass, plastic, leather and any fabric. Popular in both fine arts and commercial printing, it is commonly used to print images on T-shirts, hats, CDs, DVDs, ceramics and glassware.

Water-based, non-toxic inks, along with much finer and thinner oil-based inks, allow for longer print runs and safer working environments. Vacuum beds use a consistent suction to hold paper in place during printing. As to quality, both transparent overlays and colour blends can be printed, allowing a wider range of colour to be produced with fewer screens, and for subtle gradations of tone, resulting in high-quality, complex creations.

Events

Artists from all backgrounds are turning to screenprinting to express their creativity in new ways. To meet this rise in popularity many studios – such as the UK's Print Club London and New York's Lower East Side Printshop – allow access to their equipment for a nominal membership fee.

Left: The author at work.
Photo by Demian Smith
Right: Selecting a screen
Far right: Print Club London's vacuum beds and drying racks.
Photo by Fred Higginson

Galleries and art fairs worldwide are also recognising the demand for screenprinted work, with new events and expos appearing every year. Screenprint-specific annual events such as Flatstock, run by the American Poster Institute (API), began as a result of conversations between interested artists and collectors.

The first Flatstock, in 2002, was held in San Francisco. Flatstock has since been held every March during the South by Southwest Music Festival, in Austin, Texas. Due to demand, it has spread to annual expos in Seattle and Chicago, and made its European debut in Hamburg, Germany, during the 2006 Reeperbahn Music Festival.

In the UK, Print Club London holds annual themed shows with high-profile artists selling collectible editions at low prices. For the show *Secret Blisters*, artists' signatures were hidden to encourage people to buy the posters they liked, rather than for the artist's name. Its successor event, *Blisters Blackout*, required all exhibiting artists' work to include a glow-in-the-dark element. The venue was plunged into darkness at various points during the opening night, so the audience could see the posters' hidden glowing layer.

Events such as these are increasing the public's awareness of the screenprint scene and aiding today's resurgence of the medium as an art form.

Influence

Screenprinting is as influential in both cultural and political movements as it was during its Pop Art heyday. Both the music and fashion industries rely on the medium to produce garments and merchandise, and the screenprinted gig poster and art print scene has never been more prominent.

Furthermore, contemporary artists such as Shepard Fairey echo the sensibility of Andy Warhol's factory ethics, mass-producing collectible artwork and cult propaganda such as the Obey Giant campaign (see pp. 096–097). Fairey was also influential in producing the now iconic imagery and posters for Barack Obama's winning presidency campaign, with screenprints sold as limited-edition signed runs.

Within this book you will see how today's contemporary practitioners are not only pushing the boundaries of screenprinting as a medium, but also producing work which rivals that of any other craft or art form out there today.

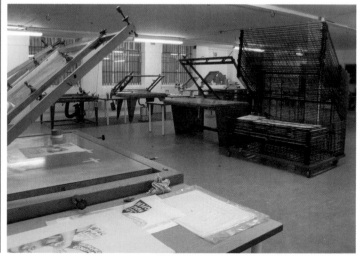

Screenprinting in Practice

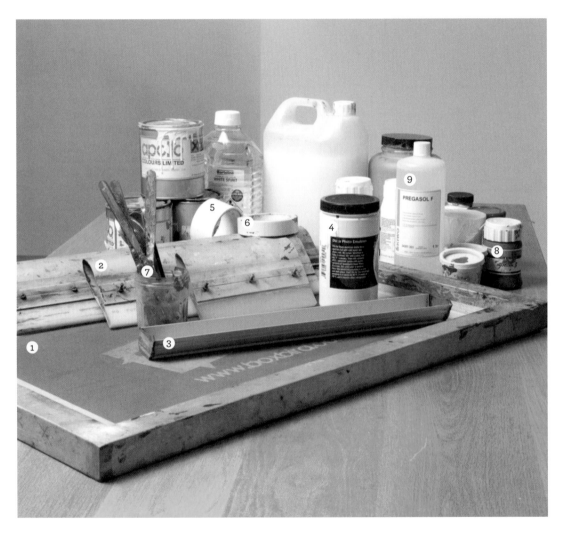

Screenprints can be created in many different ways. The most commonly used and versatile method in practice today uses photo emulsion and computer-generated artwork. This method enables you to print fine line drawings, small and detailed type and photographic imagery.

Essential equipment

01. Screen
02. Squeegee
03. Coating trough
04. Photo emulsion
05. Water-resistant tape
06. Masking tape
07. Mixing sticks/palette knives
08. Inks and media
09. Stencil strip

Coating the screen

First, coat the screen with light-sensitive photo emulsion using a coating trough. Starting at the bottom and working upwards, coat the screen in one firm, continuous movement to achieve a smooth, thin coat of emulsion. Repeat the process on the reverse side, and remove any drips or excess emulsion with a piece of card or a plastic spreader. Since the emulsion is light sensitive, leave the screen to dry in a darkroom or an area without any UV light.

Preparing artwork and 'positives'

Before exposing an image onto the screen you must create a 'positive' of your design. This is an opaque image, usually black, on a transparent or translucent surface. You can use acetate, transparent film, OHP film or tracing paper. If your design uses multiple colours, each colour separation must be printed out as a solid, opaque layer.

Exposing, washing out and spotting in

Using clear tape, secure the positives to the screen to ensure they do not move. Most screenprinting studios have industrial exposure units with a vacuum that sucks the screen down flat during exposure (see p. 010).

Once your screen has been exposed it must be washed out or 'blasted out' in a wash-out area. Use a hose with a high-pressure spray attachment, or a power hose, to spray both sides of the screen with cold water, moving the jet of water over the entire image. Where the opaque parts of the positive were exposed, the image starts to fall out. Continue until all the emulsion has been washed out. When the screen is dry, check for any holes or open areas in the design. If there are holes, lay the screen on a lightbox and use screen filler to block out these areas – 'spotting in' – so no ink will pass through them during printing. Finally, use water-resistant tape to mask off all four inner edges of the screen, to make sure no ink bleeds through the frame. The screen is now ready to use for printing.

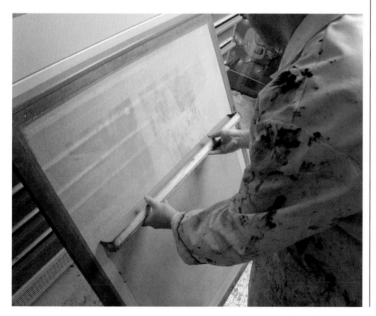

Coating the screen with photo emulsion

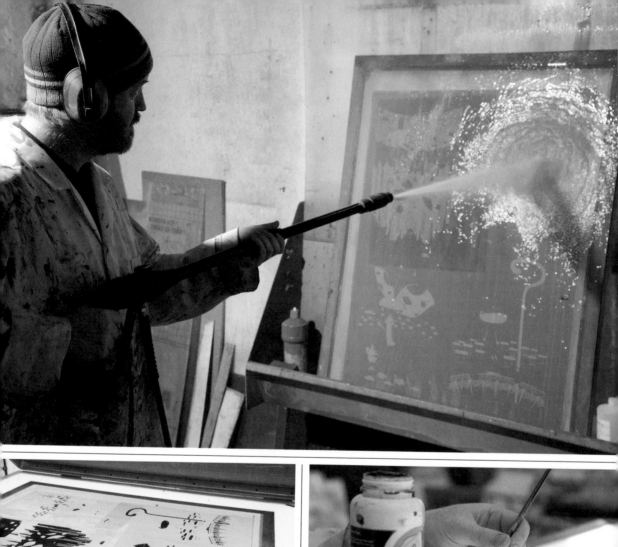

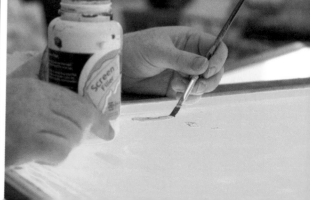

Printing

There are numerous pre-mixed inks available for screenprinting. Inks for paper are more commonly water based, or water soluble. Water-soluble inks can be bought either pre-mixed or unmixed. The base ingredient of unmixed inks is acrylic paint, which must be mixed with screenprint medium before printing. The medium acts as a retardant and ensures the acrylic does not 'dry in' on the screen and block your image.

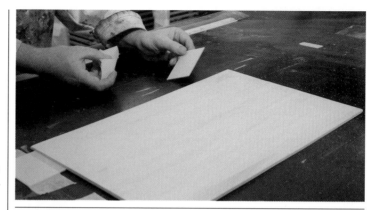

Most screenprinting studios use vacuum beds, designed to suck air through tiny holes during printing to ensure the paper is held down flat. Fasten the screen into the frame of the vacuum bed and tighten the screws on all four corners to ensure the screen does not move during printing.

When you are certain the paper is in the correct position, mark it at each edge to indicate where the paper should be placed, and cut rectangular pieces of cardboard for registration guides. These ensure that you line up and print the image in the exact same position with every sheet of paper you use. If you are printing multiple colours, guides are essential for accurate registration. Tape the guides in place and lower the frame into the printing position.

Use newsprint or unwanted old prints with a flat surface to check that the image is printing clearly. Place the

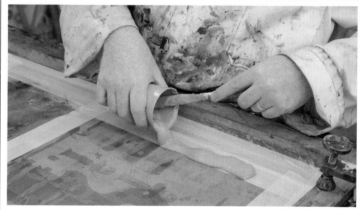

test paper in position and lower the screen into the printing position, then scoop a generous amount of ink onto the end of the screen nearest you. Lift the screen slightly so it is not in contact with the bed or the paper, and then 'flood' the ink evenly and smoothly away from you with the squeegee.

With the screen lowered into the printing position, use both hands to pull the ink forwards in one firm movement, keeping the squeegee at a 45-degree angle. Now lift up the

screen, and again flood the ink back to ensure the screen does not dry in. When you have checked the test print you can make, or 'pull', the first print onto your chosen paper stock. Then remove the print and place it in a drying rack, and repeat the process until your print run is complete.

If you are printing multiple colours you need to ensure that the next colour is correctly registered. To do this, lay a piece of clear plastic film or acetate over the paper and tape it down, then

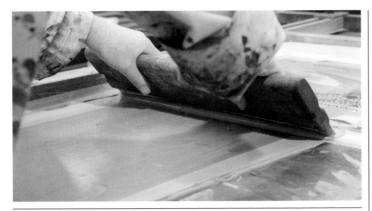

Top left: *Pulling ink forwards across the screen*
Middle left: *Lifting the screen to flood ink once more*
Bottom left: *The second colour printed onto plastic*
Right: *The finished image*

print the second colour directly onto the plastic. This allows you to position the paper with the first colour so that it lines up correctly with the new layer.

When you are confident with the registration replace the guides, and start the print run again. Repeat this process with each colour separation until the finished image is complete.

Cleaning down

You can clean all water-soluble ink from the screen with water; to remove the emulsion from the screen use a solution called stencil strip. Once you have cleaned the ink from the screen, and while it is still wet, apply a generous amount of stencil strip to the entire screen – front and back. It may help to use a brush or sponge to work the stencil strip into the emulsion and cover all areas. Leave this for a few minutes to break the emulsion down. You can then use a high-pressure hose or power hose to blast out all the emulsion until the screen is completely clear.

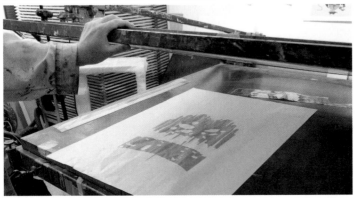

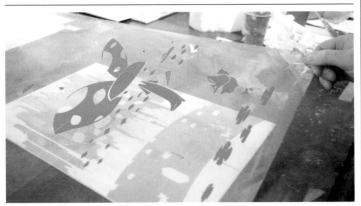

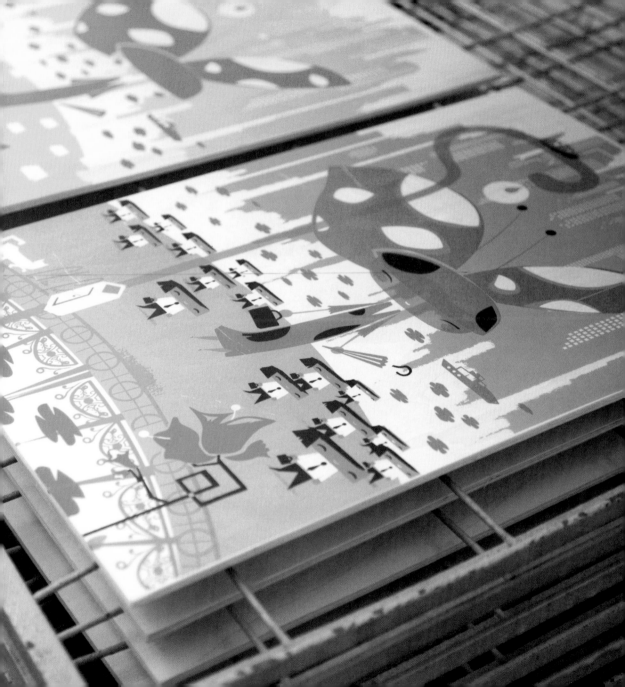

Portfolios

Doublenaut

Toronto, Ontario, Canada

This collection of concert posters was designed by Andrew and Matt McCracken of Doublenaut. The poster designed for the band The National was printed by Jesse Purcell to reflect the somber and beautiful mood of their album *High Violet*.

Matt designed The Flaming Lips poster with the idea of creating a fun image to illustrate the overall vibe of the band. It was printed on French Paper's Speckletone Cream.

The Massive Attack poster was created to promote the band's shows in Toronto. 'The image of the man's head is meant to represent an island with the "M" and "A" on either side acting as mountains,' explains Matt. All imagery was drawn in Illustrator and printed in Speedball.

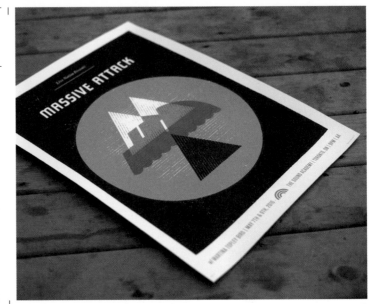

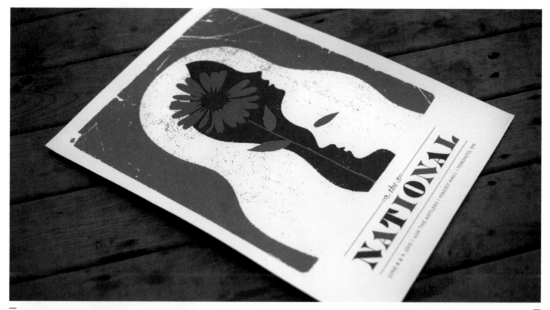

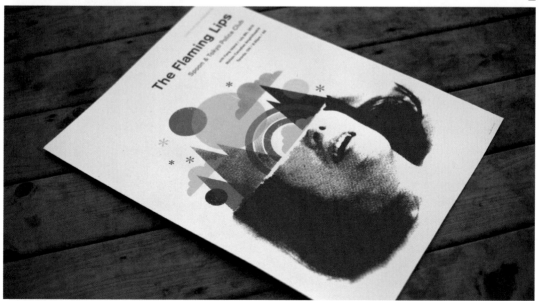

Tad Carpenter
Kansas City, Missouri, USA

This series of woodprints was created for a show at the Bluebottle Gallery in Seattle, Washington, USA. Carpenter drafted all the images by hand and then redrew them on the computer, separating out the print to have films and screens made. 'I had to cut wood to print on into sheets of c. 28 × 43cm (11 × 17in), as that is the size that fits on the T-shirt press I used to print them,' he explains.

All the prints were printed at Vahalla Studios, the silkscreen studio that Carpenter co-runs.

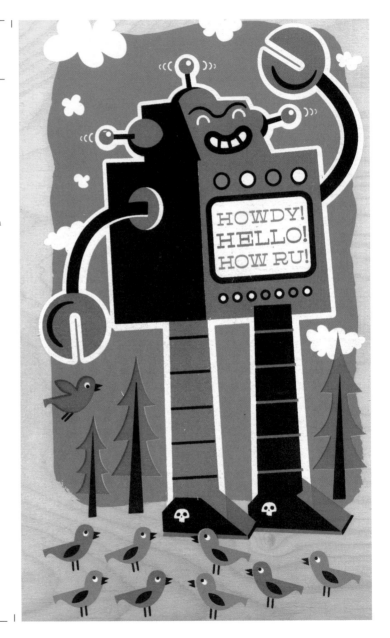

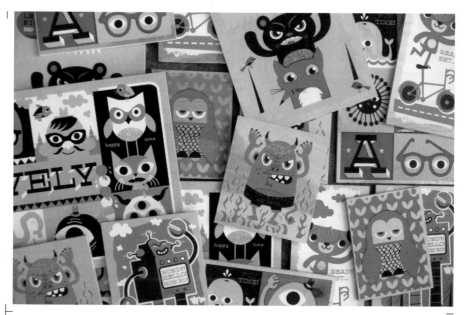

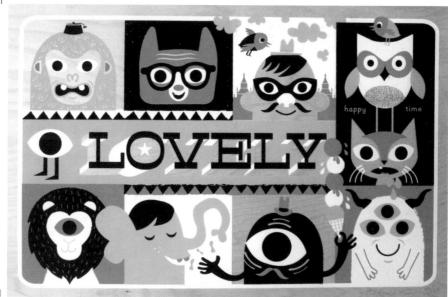

Vahalla Studios
Kansas City, Missouri, USA

The goal behind this Hello Again series of greeting cards was to create a product line that could serve multiple uses. The design process was extremely collaborative. Tad Carpenter and Dan Padavic of Vahalla Studios invited six seniors from the University of Kansas to research, sketch and develop concepts. After several months the team came up with Hello Again Greetings. Every card can be used again; simply tear off the perforation at the spine and pass it on to a friend.

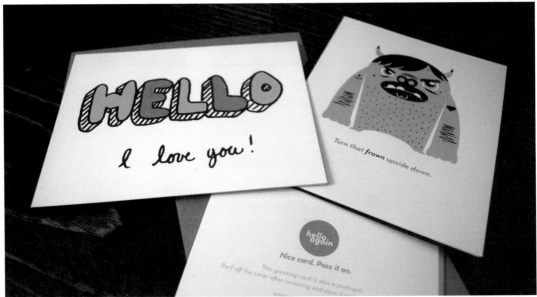

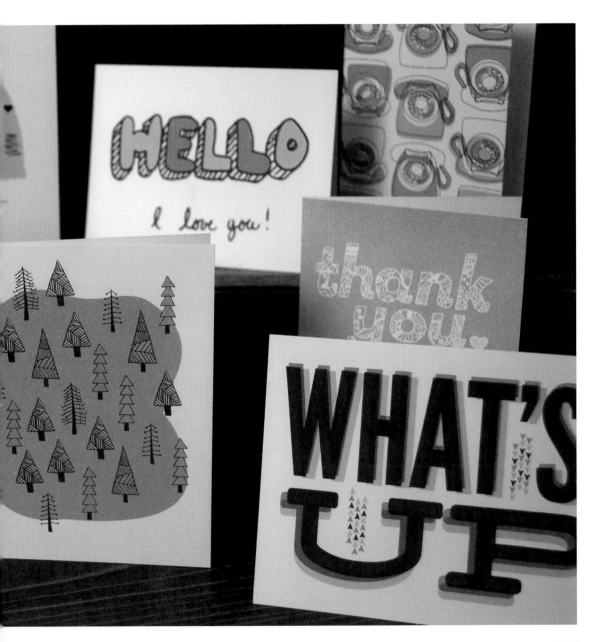

Robin & Mould
Market Lavington, England, UK

Amy Robinson and Christian Mould designed the Sleepy Owl cushion as a companion piece for their Sleepy Dog. Inspired by mid-twentieth-century illustration and Scandinavian design, the images were sketched by hand before being reworked in Illustrator and printed onto acetate, ready to expose the screens. The designs were printed onto a natural linen-cotton blend, which was cut to size, using Permaset Aqua water-based inks. The felt feet and wings were all cut by hand and sewn into the cushion, which was then stuffed and finished by hand.

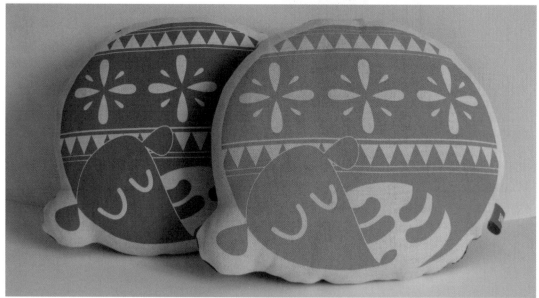

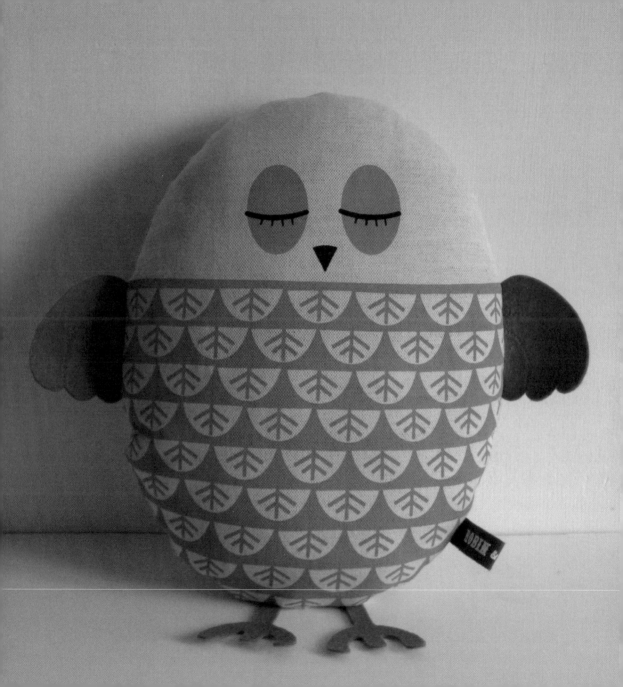

–V– Workshop
Barcelona, Catalonia, Spain

Joan Tarragó and Marga López of
-V- Workshop created these limited-
edition cusion covers to inject some
personality back into the home.
'We believe that an artwork doesn't
need to be hung on the wall,' explains
Tarragó. Each cover was handmade from
start to finish. The image was printed
onto white cotton with black textile ink
through a 43T textile screen. The fabric
was printed before the cushions were
sewn up.

The packaging shows -V- Workshop's
cheap and effective DIY solution to
housing limited-edition screenprinted
T-shirts. Having measured all the parts
of the unfolded box, they proceeded
with the layout of the packaging. They
created a 2-D illustration and printed
this out on an accurately measured
layout to use as a photolith for the
preparation of the screenprint.

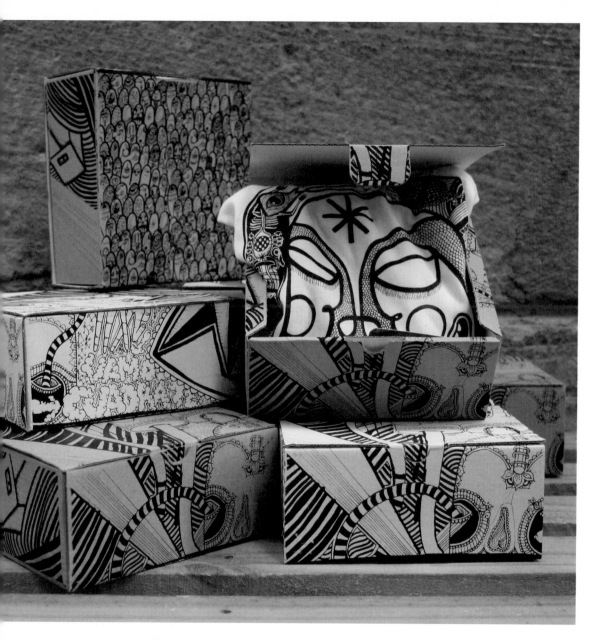

Le Dernier Cri
Marseille, France

Studio Le Dernier Cri created this OXO book with artist Blex Bolex. The concept was to make an object with many flaps that can be folded to give an infinite combination of images. The book was screenprinted in its entirety with multiple colours. The meticulous work of binding the book flaps together *and* to the cardboard back cover was done by bookbinder Vanessa Krolikowski.

The wooden box was produced to house nine comics. A drawing by Pakito Bolino of Le Dernier Cri was printed in six colours, in a limited edition of 200.

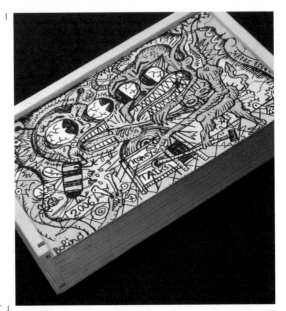

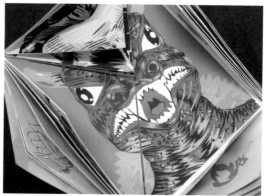
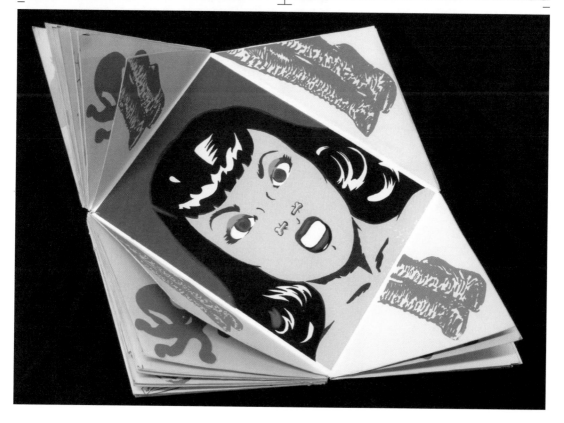

Cricket Press

Lexington, Kentucky, USA

These coasters were designed by Brian and Sara Turner of Cricket Press. To meet the registration challenges of printing a two-colour design on a circular object, they created a registration template from chipboard. Their press table can hold four coasters at a time and, by taping the registration template to the table, they can ensure proper placement for each during the printing process. The coasters – thick pulp paper stock – were purchased as die-cut blanks and printed with Speedball Permanent Acrylic inks. 'The ink does not bleed or fade when the coasters get damp from normal use. They hold their colour perfectly!' explains Sara Turner.

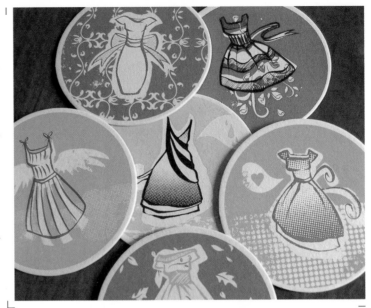

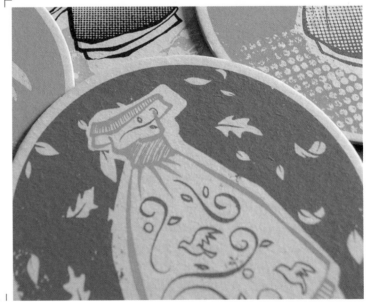

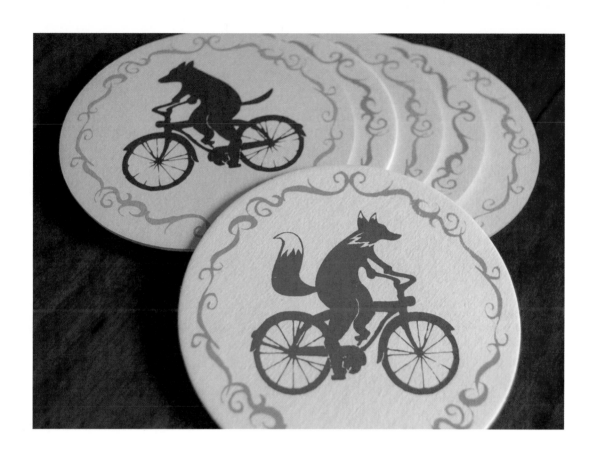

Mingus Designs
Melbourne, Victoria, Australia

The bags and cushions pictured here were created by
Dear Songsuwan of Mingus Designs as part of a range
of items – including bags, cushions, purses and scarves
– centred around screenprinted designs. All of the designs
evolved from sketches, with a handcut stencil of the final
design produced for printing onto linen with water-based ink.
Once cured, the prints were combined with black hemp
and made into bags and cushions, etc., in the studio.

Mashville

Amsterdam, the Netherlands

Mashville is the collaborative brainchild of Dutch designers Mister Adam and drJay. All of their posters are created through collaboration with other artists via email. This poster is the result of a collaboration between Mashville and Machine. The artists all work in different ways, using anything from markers, pen and ink, brushes and paint, paper cutting or digital drawing, with the work-in-progress emailed back and forth until ready to print. 'Working this way really keeps our minds open; it challenges us each time we get an email with an image back to work on,' explains drJay.

House Industries
Yorklyn, Delaware, USA

Andy Cruz is a designer with House Industries, and the wooden fish shown here were designed in conjunction with his lecture tour of Japan. Each koi was cut on a bandsaw, sanded, stained with furniture-grade lacquer then screen-printed with a mix of flat and metallic inks in House Industries' Grand Rapids studio. The printed patterns were built with typographic elements derived from House Industries and Photo-Lettering fonts. Century-old reclaimed pine and other soft- and hardwoods were used to create the koi.

The Alexander Girard Nativity set was based on an illustration that House Industries' researchers found in the spare bedroom of Alexander's son's house. (Alexander Girard was an influential designer in post-war America, best known for his textile designs.) Each of the 13 pieces was handprinted onto solid maple, with child-safe, non-toxic inks. The stable was manufactured from replenishable, Michigan-grown basswood. An ambitious and complicated project on every level, the Nativity requires over 70 individual screen pulls.

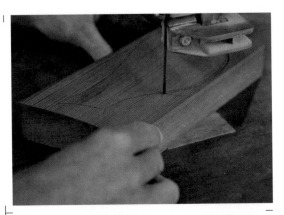

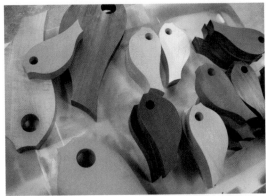

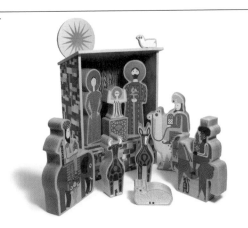

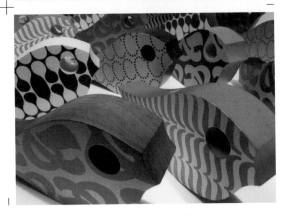

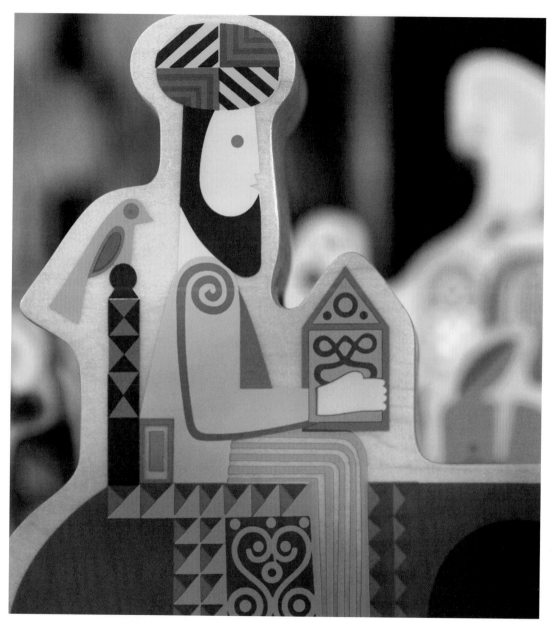

Hero Design Studio
Buffalo, New York, USA

Hero Design Studio is husband-and-wife team Mark and Beth Brickey. Their *Brooklyn* poster was created for Hero's visit to the renegade Brooklyn Arts Festival. They created the poster 'in the hope of sharing our vision of America's best neighbourhood with those who live there,' explains Beth Brickey. Hero created a reference image with Google Maps Street View, taking their favourite houses and creating a fictional city block.

The poster for the band St. Vincent was designed as a keepsake for those fans who attended the Pitchfork Music Festival. Starting with a hand-drawn Victorian house, Hero then used the computer for the composition, and once the look was complete those elements were drawn and added back in before printing.

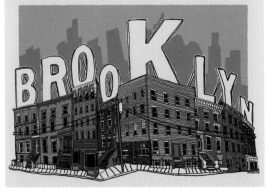

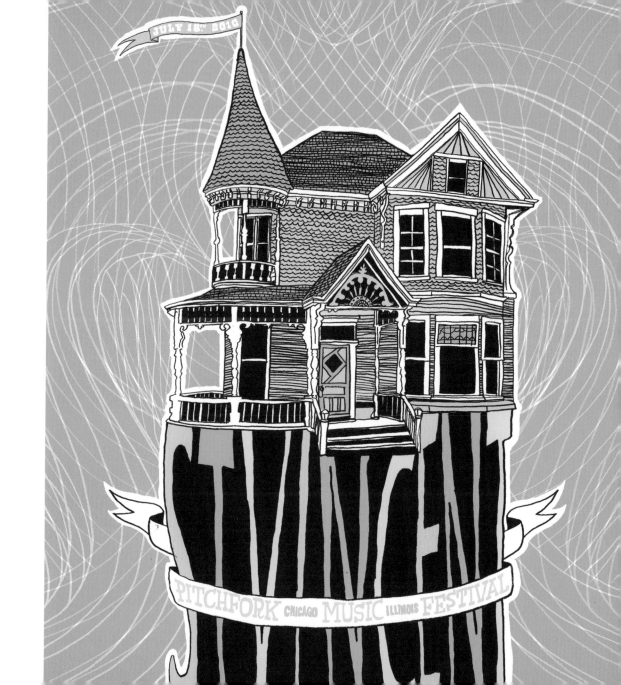

Heather Lins Home

Madison, Wisconsin, USA

Heather Lins worked with 3-D comic-book artist Ray Zone to produce these 3-D eyechart cushions. The cushion fronts were cut from 100-percent cotton and screenprinted using water-based ink. The fronts and backs were then sewn together with a care tag, a logo tag and a hidden zip. Once stuffed, Lins' final touch was to attach a hangtag that includes 3-D glasses. Lins explains that one challenge was evaluating the cushion design. 'I sometimes got a headache wearing those glasses for long periods of time!'

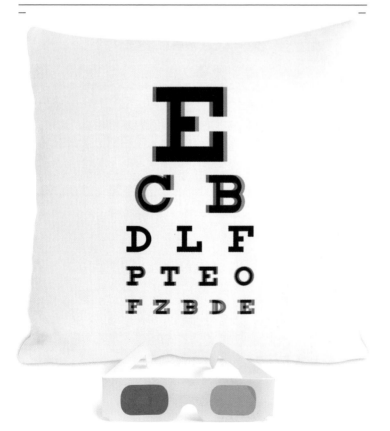

A. Micah Smith Illustration & Design

Gardner, Kansas, USA

This poster, created for Dinosaur Jr.'s Secret Show in conjunction with Myspace, is printed in a four-colour CMYK process. 'I scoured old skate images and magazines, compiled them into a final collage and then separated the files into the colour channels so the printing process shows the design as full-colour photos,' explains Smith.

His approach to The Get Up Kids poster was to build a rabbit face out of chemistry equipment, to represent the title of the band's EP, *Simple Science*.

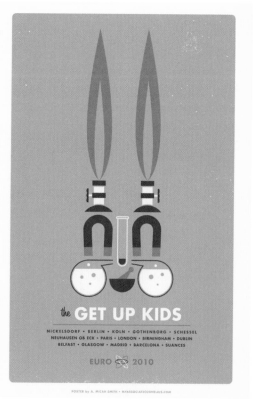

Mikey Burton
Philadelphia, Pennsylvania, USA

This commemorative poster was designed for the band Wilco's performance at the Greek Theatre in Berkeley, California, USA. The bookshelf visual was inspired by the well-read student population of Berkeley. Burton's main challenge was to ensure that the shelf image clearly related to Berkeley, which he achieved by incorporating the town's iconic campus clock tower. The design was produced using Illustrator and then texturised manually.

The design for the Richard Buckner poster was inspired by the country-and-western influence of Buckner's indie sound. It is a c. 46 × 61cm (18 × 24in), three-colour screenprint on French Construction Whitewash paper.

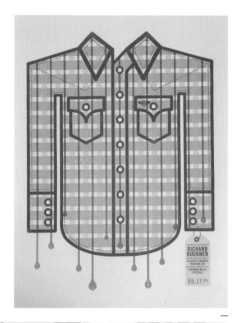

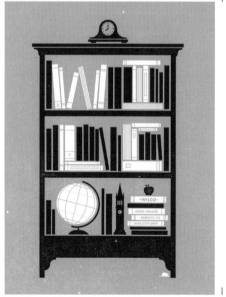

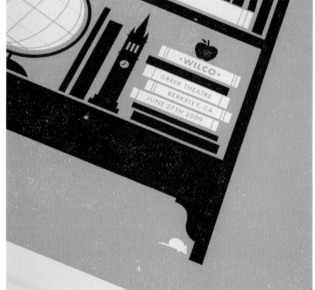

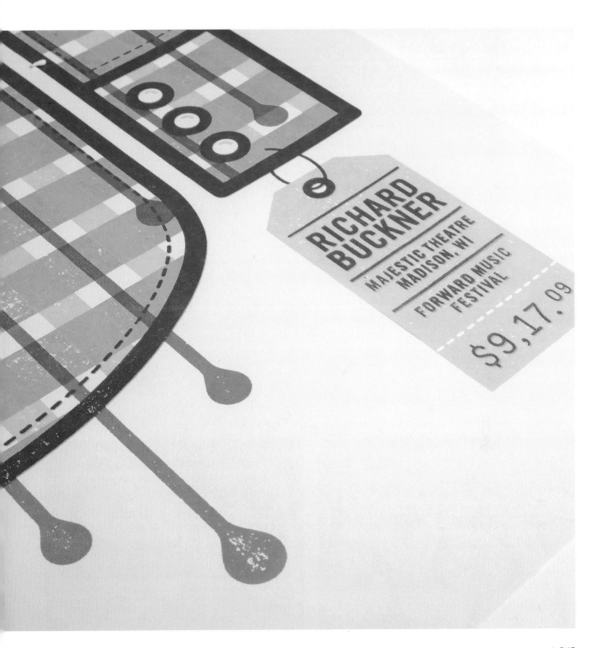

RICHARD
BUCKNER

MAJESTIC THEATRE
MADISON, WI

FORWARD MUSIC
FESTIVAL

$9.17.09

Methane Studios

Sharpsburg, Georgia, USA

Methane Studios' Mark McDevitt and Robert Lee created this *All Hallows Eve Skull* print, the studio's first major seasonal artwork. The pair collected a series of test prints and created two different one-colour designs, inspired by vintage German Halloween decorations. By printing over other test prints the work acquired a unique edge, with some pieces including partial prints of two or three other posters.

Lee designed The Black Keys poster to reflect the band's great pride in their home town – Akron, Ohio, USA – known as 'Rubber City' and home of Goodyear, maker of the Zeppelin. 'I began by researching different blimp shapes,'

Lee explains. 'Once I was satisfied with the drawing I scanned and vectorised it, then used big halftone dots to give a look reminiscent of punk-rock flyers created on a Xerox machine.' Lee printed three inks on c. 41 × 81cm (16 × 32in) French Cement Green Construction paper.

Lee also created this poster for the band Beach House. The goal was to design a work that reflected the band's music – mysterious and moody, as well as poppy and dreamy – and the concept is based in part on the band's song 'Zebra'. 'Zebra stripes were used for texture as well as a spot varnish to give the image a ghostly and trippy feel,' says Lee.

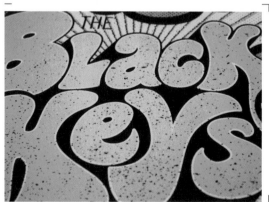

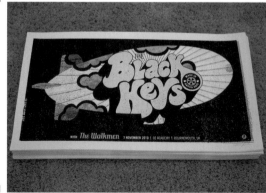

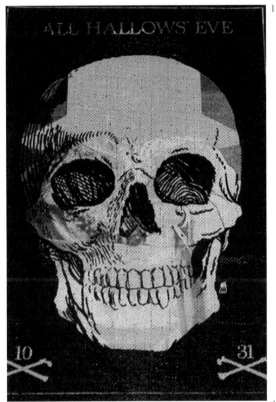

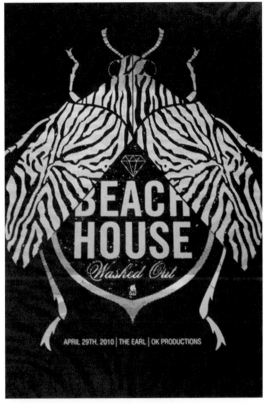

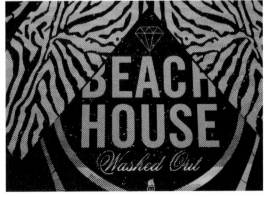

Steady Print Shop Co.
Minneapolis, Minnesota, USA

America! was designed by Erik A. Hamline of Minneapolis-based Steady Print Shop Co. 'I have a profound love and fear of this great nation and decided to make a boisterous print to express that,' Hamline explains. The textures were created through a combination of lots of scanning, photocopying, dry-rub transferring, ripping, painting and crumpling. The results were then printed in three colours – medium red, metallic silver/cool black mix and white/yellow – on 100lb French Whip Cream paper. The *No White Girls* print is the first in a series of 10 signs entitled Quit Life! 'The prints were all meant to offend lightheartedly and make folks smile. And to pay for booze,' says Hamline. All the type was hand painted with screenprinting ink and dry brush, then printed in three colours – orange, metallic silver/black mix and cream – on 140lb French Muscletone Whip Cream paper.

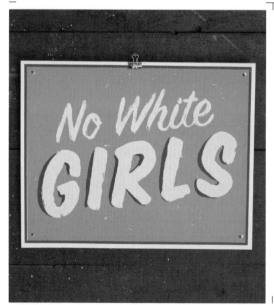

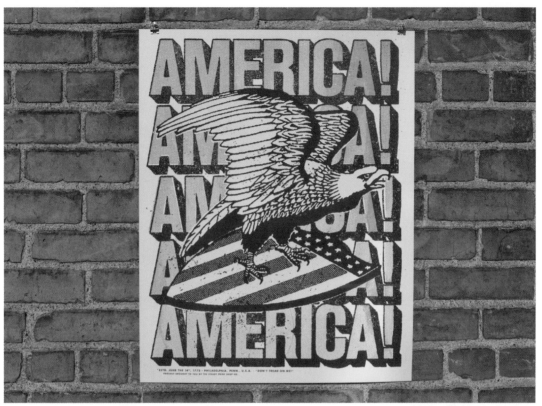

Martin Ernstsen
Berlin, Germany

Martin Ernstsen created this entirely screenprinted concertina book for his master's degree final piece at Konstfack University College of Arts, Crafts and Design in Stockholm, Sweden.

The piece, entitled *Kodok's Run*, demanded a lot of planning as it consists of one big silk-screened image, with a total width of around 13m (42ft). 'I had to calculate a lot, and binding it was perhaps the biggest challenge,' explains Ernstsen. The original drawings were made in ink, and the colour separations were then made in Photoshop before the book was printed on-site at the University.

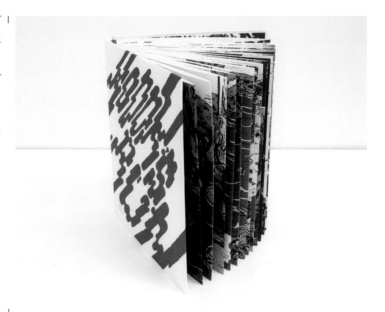

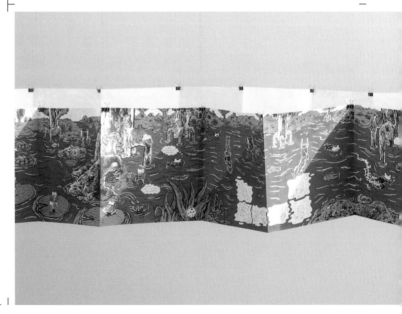

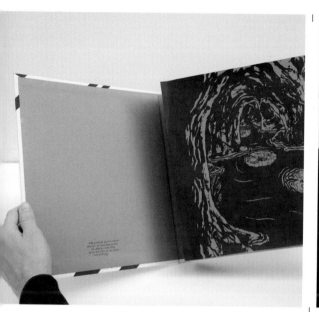

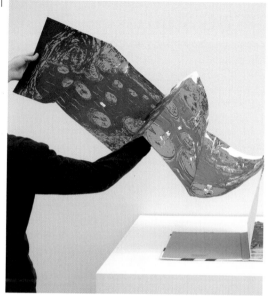

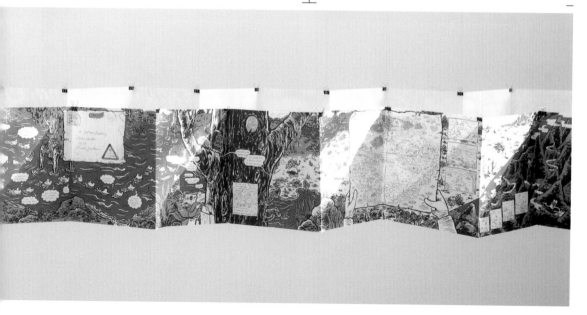

DKNG Studios
Santa Monica, California, USA

Dan Kuhlken and Nathan Goldman of DKNG Studios created this poster for the band The National's show at the Marquee Theatre in Tempe, Arizona, USA. The concept was to portray a popular pastime in one of America's hottest states by showing an aerial view of a public pool. The lone swimmer reflects the band's lonesome and melancholy sounds.

The image was created entirely in Illustrator before all the textured parts were bitmapped and halftoned. The shadows cast by the pool's partitions were created by the teal ink overlaying the paper's colour, while the teal of the pool was created using teal ink overlaying white ink. Danny Askar printed the poster in four colours.

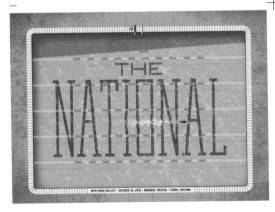

DKNG designed this poster for the group art show, Synth, held in Asheville, North Carolina, USA. All proceeds from the show went to the Robert Moog Foundation. 'Our goal was to portray Robert Moog's grand achievements by showing an enormous synthesizer with an empty chair in remembrance of Moog himself,' explains Kuhlken. The poster was printed in four colours by Danny Askar on 100lb French Pop-Tone Red Hot paper.

HumanShapedRobot

Cornelius, North Carolina, USA

Designer Jamie Reed – HumanShapedRobot – created this *Uncle Franks* art print, reminiscent of vintage hair treatment advertising of the 1950s and '60s. When designing his prints Reed usually has a general audience in mind, and always tries to imagine where the print might be displayed once it's been purchased. 'I pictured this print in a bathroom, pub, barber shop or any other manly area,' he explains. The final design was printed in flat black acrylic ink on French Kraft paper.

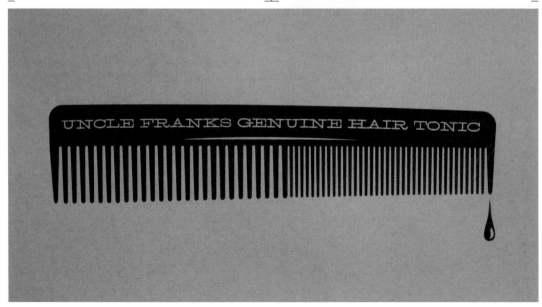

Patswerk
The Hague, the Netherlands

Graphic design and illustration agency Patswerk was invited to take part in the exhibition Don't Believe the Type. Founding member Lex Van Tol explains, 'As it was about typography-based artwork, we decided to make a pipe saying "Don't believe the pipe" as a reference to the famous Magritte painting, *Ceci n'est pas une pipe* (This is not a pipe).'

The second design, a self-initiated art print, was hand drawn, scanned and edited in Illustrator, and screenprinted in two colours on 200gsm heavy paper. 'We tried to make maximum use of the two colours, so we included lots of halftone patterns in the design,' says Van Tol. Both posters were printed by Patswerk at the Graphical Workshop, The Hague.

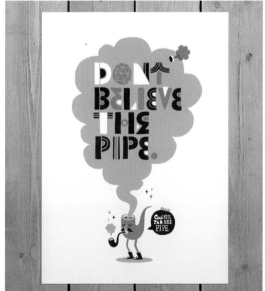

Gregory Gilbert-Lodge
Zurich, Switzerland

Gilbert-Lodge produced these one-off gifts to friends using a variety of media and materials. *2CV*, named for the iconic Citroën car, was screenprinted black and turquoise on a metal aluminium board. After screenprinting, the image was spray varnished several times to get a glossy surface.

The second image was inspired by Gilbert-Lodge's trip to Africa and the photographs he took there. Describing the process from camera to print, he explains: 'First I take various photos of the object I want to draw. Afterwards I make a collage with the photos and then I draw a rough design with black ink on paper using the photo collage as a rough guideline and finish off the design digitally with Photoshop.' The image was screenprinted red and black on a yellow wooden board.

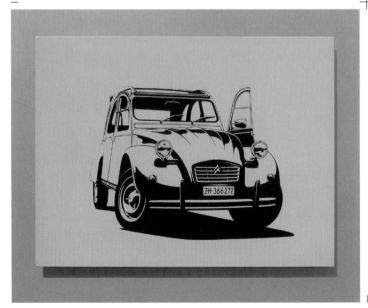

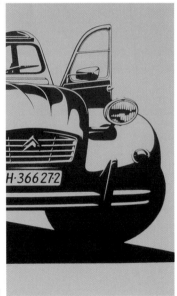

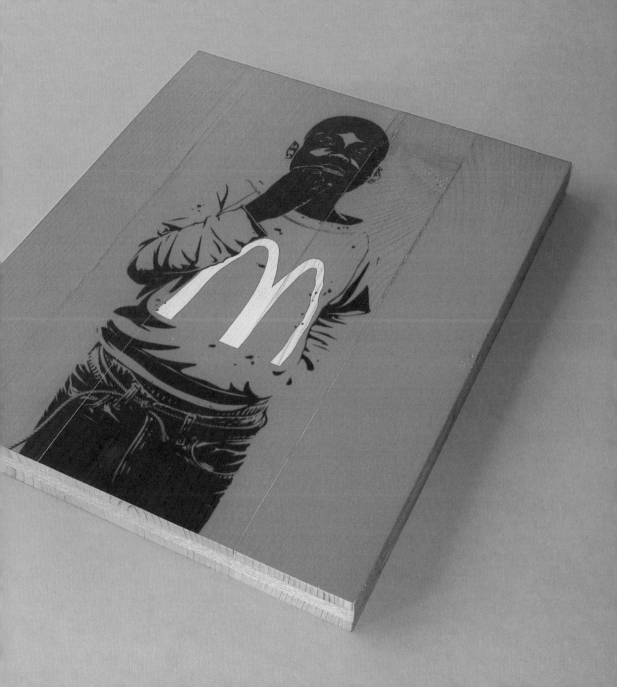

MouseSaw
Minneapolis, Minnesota, USA

Lucas Richards and Adam Leick of MouseSaw create functional pieces of screenprinted art, ranging from games and homeware to furniture – even grandfather clocks. 'We always start our design process with a rough sketch,' Richards explains. 'Adam Leick, our woodmeister, creates the pieces and gets them to me for screenprinting, then I ship them back to him for all the finishing work.'

The desire to create a piece about how to brew beer inspired this coaster set. The case and each of the coasters shows a scene from MouseSaw's own imaginary brewery.

The table, *MouseSaw No. 9 (Dead Men Tell Tales)*, was inspired by a session with a Ouija board, and took six months to complete. Towards the end of the project the tabletop mysteriously cracked, though to MouseSaw's delight it didn't split.

Leick's love of logic games inspired *The Tower of Hanoi*. This involves moving discs from one side of the board to the other without putting any larger discs on top of smaller ones. MouseSaw also screenprinted a four-page instructional booklet to go with the game.

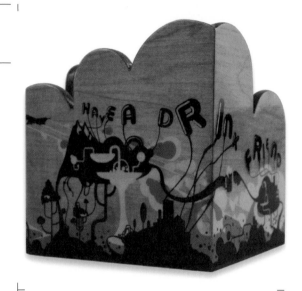

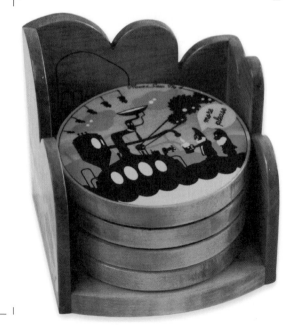

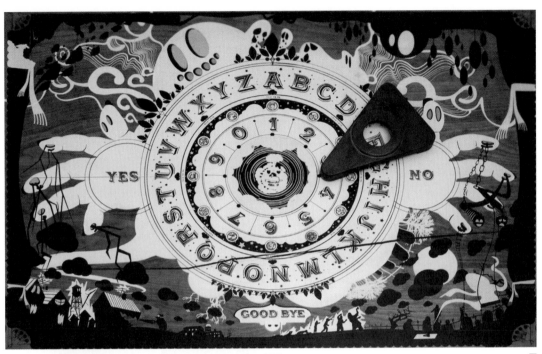

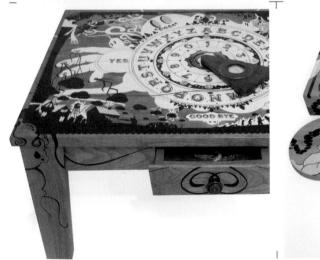

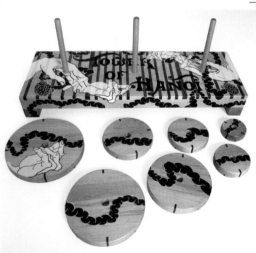

The Small Stakes
Oakland, California, USA

The Small Stakes, Oakland-based designer and illustrator Jason Munn, created this poster for the Minneapolis show of the band The National. A three-colour screenprint using metallic silver, transparent grey for the shadow and purple, the poster was printed on off-white paper.

Munn designed all these posters using Illustrator. 'Most of the work starts in the form of rough sketches,' he says of his design process. 'I then spend most of my time in Illustrator creating the final design before separating the colours and beginning the screenprinting process.'

The She & Him (musicians Zooey Deschanel and M Ward) poster was designed to promote a live show. The final two-colour poster was printed with metallic gold and black ink on off-white paper. Bloom Screen Printing Co. of Oakland, California, printed all three posters.

Munn was asked to create this Mark Kozelek poster to sell during Mark Kozelek's Scandinavian tour. It is printed with three colours on white paper.

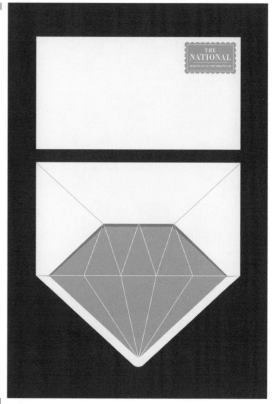

SHE & HIM

MAY 29, 2010 / with THE CHAPIN SISTERS / FOX THEATER / OAKLAND, CA

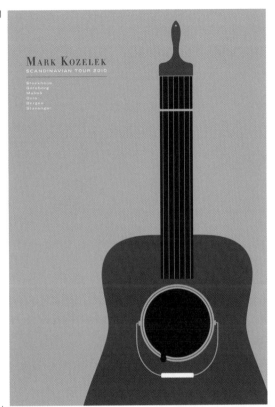

MARK KOZELEK
SCANDINAVIAN TOUR 2010

Stockholm
Goteborg
Malmö
Oslo
Bergen
Stavanger

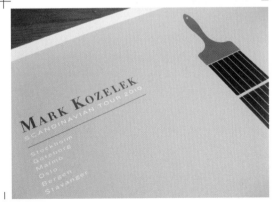

Joe Wilson
Leicester, England, UK

The poster for Decoy.tv was designed to represent the ethos of this motion-design company. Using the word 'decoy' and its meaning as a starting point, Wilson produced a highly detailed artwork where all is not what it seems. 'I started by customising the company logo, then built up elements around that from ideas I'd had from talks with the company and creative input from Ryan Rothermel of Decoy,' explains Wilson. The posters were lovingly screenprinted in Portland, Oregon, USA, by Justin Dickau.

The leafbird poster was designed for a show curated by Print Club London, UK. All the elements were hand drawn in pen and ink and coloured on the computer, then printed in a limited colour palette with a colour blend.

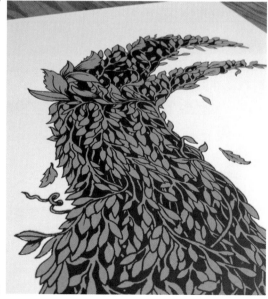

Cut–Out

Birmingham, England, UK

Designed by Kay Stanley, these tote-bag illustrations were Cut-Out's first two designs and remain their most popular to date. The first prints were produced on a homemade screen and press in Stanley's parents' garage; the most recent were made in Cut-Out's newly established GET A GRIP studio, on a properly made screen, and printed on their six-colour carousel. All totes are printed using water-based inks. The only differences between print runs are the labels on the back – the telltale sign of when and where they were printed.

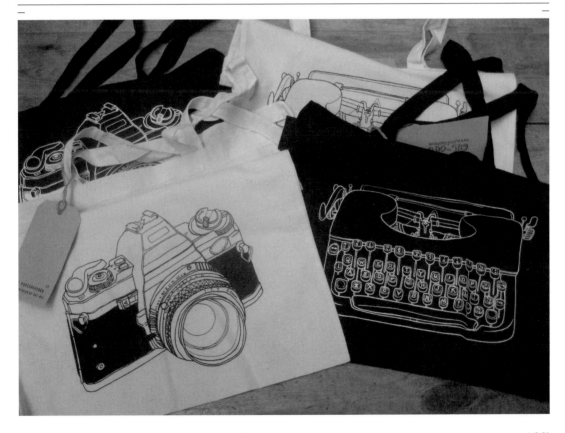

Dan Stiles
Portland, Oregon, USA

The *Circus* poster was designed for the band Death Cab for Cutie. 'I had the design sketch kicking around for a long time,' explains designer Dan Stiles. 'When I saw the circus-themed art Death Cab was using for their tour I knew it had found a home.' Stiles liked it so much that he taped off the type and made a few as art prints.

Inspired by Spoon's song 'I Turn My Camera On', the poster far right evolved from some pattern experiments Stiles made with bits of cut paper. 'I didn't do much sketching as I was working from a hotel room in Mexico on a tight deadline,' says Stiles. 'I had the idea and I just went for it using Illustrator.' Both posters were printed by Good Thoughts Printing of Boulder, Colorado, USA.

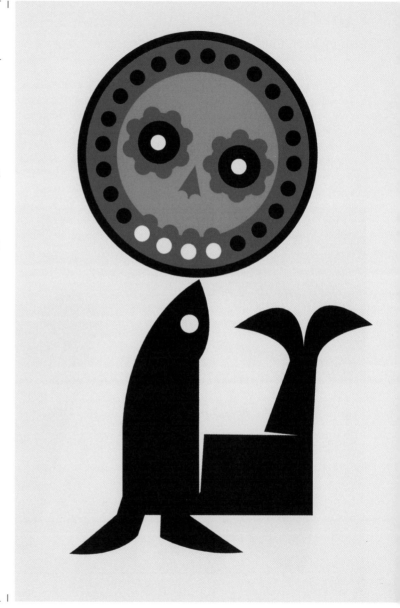

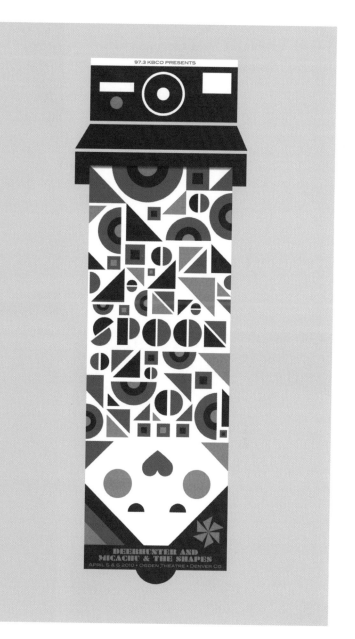

Two Guitars Art Cards

Portland, Oregon, USA

Scott Ballard creates screenprinted art cards and notebooks from his studio in Portland, Oregon, often printing on a Japanese Gocco Press. Ballard begins by conceptualising his work in Photoshop before often redrawing it by hand, and then preparing it for print. His cards and notebooks are sold through the Two Guitars Etsy shop and at art shows throughout the year.

Ellie Curtis

London, England, UK

Printmaker and illustrator Ellie Curtis designed and printed these two cushions: *Victoria Parade*, printed in black, and *Birdjig*, in red. 'With the *Victorian Parade* design I had a specific idea, but the *Birdjig* design happened quite spontaneously,' explains Curtis. 'With both designs I drew directly onto a heavy-weight tracing paper and exposed this directly onto a screen. I then screenprinted onto cotton drill fabric using pigment inks mixed with textile binder. Finally I made up the cushion covers with my sewing machine and overlocker.'

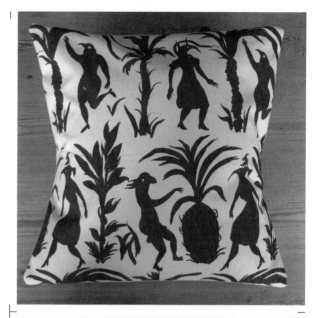

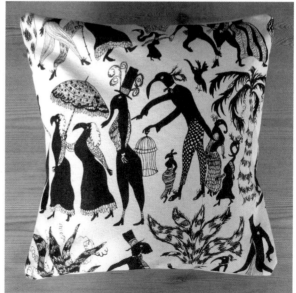

Bongoût
Berlin, Germany

Anna Hellsgård and Christian Gfeller, of Bongoût's creative twin Re:Surgo!, created the book *Miel de Fond* in collaboration with Stéphane Blanquet. 'We have been huge fans of Stéphane Blanquet, the iconoclastic cult French illustrator, for many years,' explains Hellsgård. 'It is a nice anniversary marker for Bongoût that in our fifteenth year we were honoured to work on this book with him.' Each page in *Miel de Fond* is printed with three to four colours on 300gsm white stock. The cover was printed on 350gsm grey stock.

Bongoût was approached by Norwegian noise band MoHa! to design a record sleeve. 'Their music can seem chaotic at first but is actually very precise,' says Hellsgård. 'We tried to transpose their sound into our graphic world.' The 12-page silk-screen booklet that houses the record was printed using water-based ink on 300gsm white stock, with an edition of 300. Le Petit Mignon oversaw curatorial duties on the project.

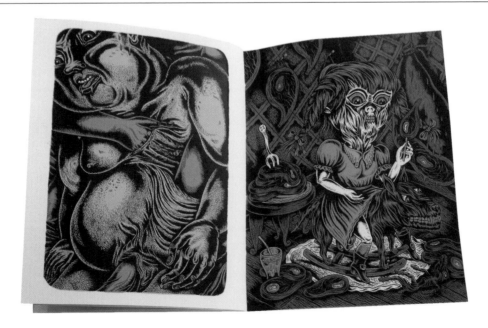

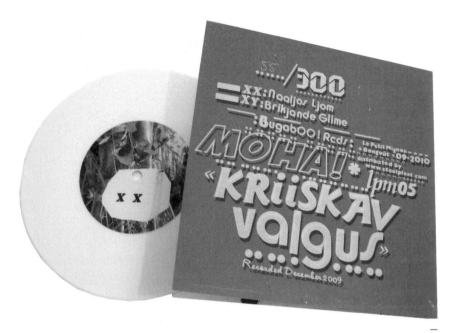

Seb Lester

London, England, UK

Type designer, illustrator and artist Seb Lester created his *Stars* poster (right) after being inspired by a quote from Vincent van Gogh. 'The words had an immediate resonance with me and I knew I had to do something with them,' explains Lester. On close inspection you can see that the lettering he developed is made up of clusters of tiny stars. The finished work was printed with metallic gold ink on midnight blue plike (plastic-like) 330gsm paper.

With *Dreams* (far right) Lester really wanted to push himself both creatively and technically to produce something striking, intricate and beautiful. He developed and drew the five lettering styles from scratch. 'I was inspired by some of the finest lettering in history but aimed to produce work that looks contemporary, stylish and relevant today', he explains. *Dreams* was printed with glossy metallic black ink on bright white plike 330gsm paper. Both prints have a limited run of 100, and are A2 size (42 × 60cm/16¹/₂ × 23¹/₂in).

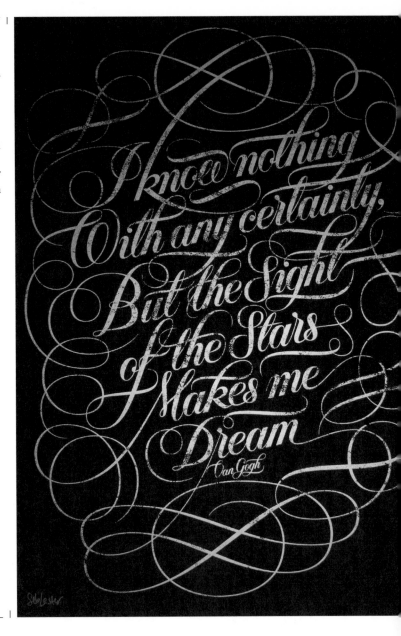

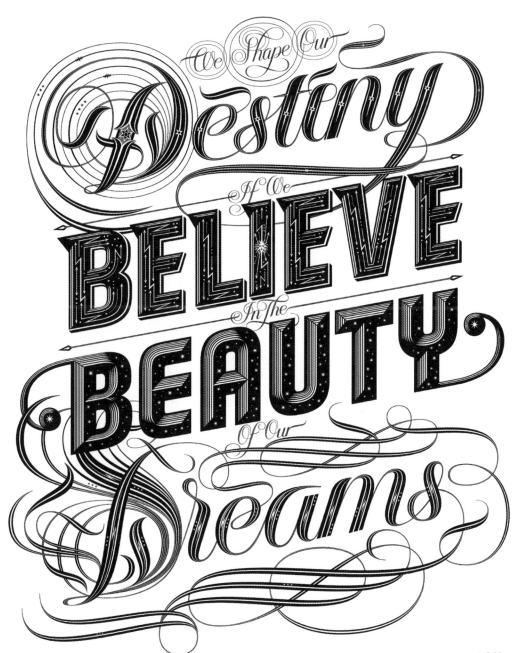

We Shape Our Destiny If We BELIEVE In The BEAUTY Of Our Dreams

Anna Lincoln
London, England, UK

Artist and designer Anna Lincoln created these prints on wood for the Deptford X Arts Festival, UK. Entitled *The Last Orders* series, they aim to highlight the rapid closure of pubs in parts of London, and show the ways these buildings are repurposed after their closure. Lincoln first took a photographic record and researched the history of each individual pub, before producing vector drawings to create architecturally accurate works. The final designs were screenprinted in two colours onto sanded wood.

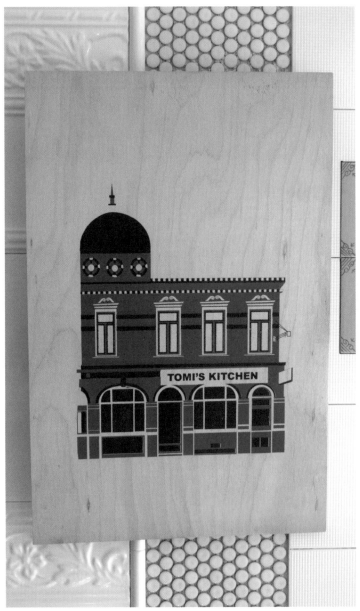

Craig Redman (Rinzen)
New York, New York, USA

Craig Redman of design studio Rinzen created *Stevie, London* as part of an ongoing series of portraits of friends and acquaintances. Redman started by photographing his friend, then recreating the image in the Freehand program. Kayrock Screenprinting in Brooklyn, USA, did the final printing.

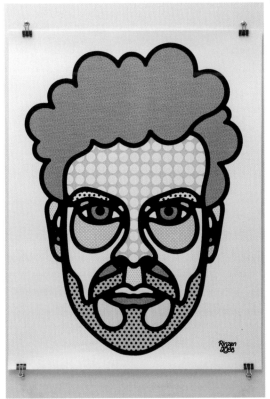

Crosshair
Chicago, Illinois, USA

Chicago-based Dan MacAdam, a.k.a. Crosshair, produces photorealistic silk screens using complex spot-colour separations and transparent overlays. This poster was created for the band Wilco. Since Wilco is a distinctly Midwestern band, MacAdam chose the grain elevator featured in the design as a classic Midwestern image. MacAdam started by photographing the subject from all angles to find the most iconic composition, then separated the design into seven print colours. It was printed on 80lb Wausau Bright White Cover using TW Graphics water-based inks.

The art print entitled *Fort #3* is the third in a series MacAdam created to depict box-like structures in isolated settings. The print uses ten inks, including seven transparencies for overprint effects. 'All of my photo-based work uses my own original photography,' says MacAdam. 'I avoid halftones and CMYK process as a rule, preferring to explore other methods of creating stimulating full-colour images.'

All the artworks were printed on Crosshair's old Lawson Geniette Press.

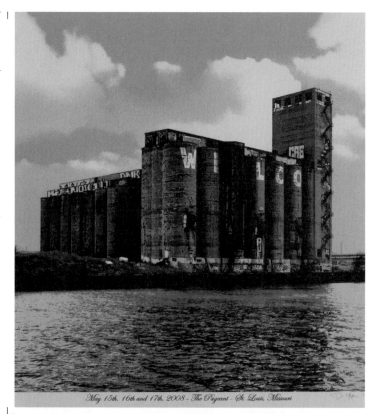

May 15th, 16th and 17th, 2008 - The Pageant - St. Louis, Missouri

Snowblinded

Lakewood, Colorado, USA

The *Drop Sequence* poster was created by Colorado-based Anthony Cozzi, a.k.a. Snowblinded, as part of Artcrank, a showcase of affordable art inspired by bicycles and the sequence photography found in BMX magazines showing how particular tricks are performed. It was printed using three Pantone inks on 100lb paper.

Cozzi designed the *Polygon 30* poster using the Cinema4D program. 'After producing the 3-D artwork I redraw it with pencil to flatten and simplify the illustration,' he explains. Cozzi then scans the drawing into Photoshop for final colouring and preparation. *Polygon 30* was printed with two Pantone inks on 100lb paper.

The posters were printed at Seizure Palace in Portland, Oregon, USA, and were photographed by Gabe Re.

The Decoder Ring Design Concern

Austin, Texas, USA

The Decoder Ring Design Concern collaborated with Michael Sieben to produce this ambitious print. With their Print Project collaborations, Decoder encourages the artist to make each colour separation by hand on film or vellum. 'Some of the first films were made by dripping ink down the full-size film. Then we mixed coffee into a clear base medium to recreate a "tea stained" drip look,' explains Decoder's printer, Paul Fucik. 'Towards the end of the print we added a couple of layers of various gloss varnishes. On top of the orange "furry" layer we printed a cold wax, which gives a really matt finish and some tactile interest when you run your finger across it.' The final print includes 20 colours.

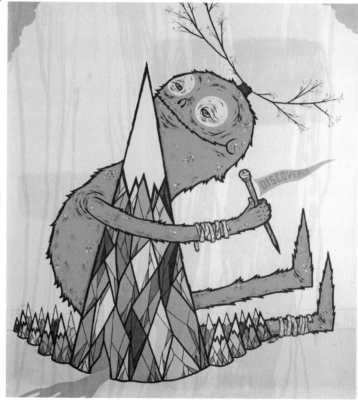

Susie Wright
Edinburgh, Scotland, UK

Illustrator and printmaker Susie Wright began experimenting with overlaying colours while creating a series of screenprints of British birds. For the first, *Woodpecker*, Wright developed a black-and-white line drawing from her original pencil illustration, which she then blocked in to create the top black layer. In the subsequent two prints – *Teal Duck* and *Hen* – she drew each colour layer by hand to fit the previous printed layer. The black layers were the last printed, with Neptune ink, which is slightly glossier than the Golden inks used for the colour layers, on 300gsm Somerset Satin White stock.

Tom Frost
Bristol, England, UK

Tom Frost is part of Snap Studio, a screenprinting cooperative and gallery based in Bristol, UK. *The Wrestler* is a four-colour screenprint on laser-cut wood. Frost's aim was to create a screenprint that could be treated not only as a traditional print to hang on the wall, but also a tactile 3-D object. Each wrestler is signed and comes in its own box.

The rocket ship was created by Frost as self-promotion and to sell through galleries. The slot-together design is screenprinted in four colours onto laser-cut plywood. The edges were hand painted and then a coat of varnish applied. 'I designed the rocket to stand upright in the "takeoff" position, and to hang from the ceiling for the "flight" position,' explains Frost.

Also shown here are two of Tom Frost's Car designs. These are made from layers of carved plywood and coated with a screenprinted skin.

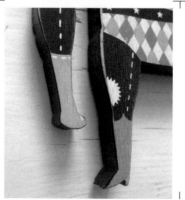

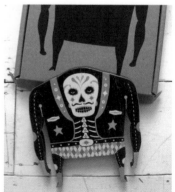

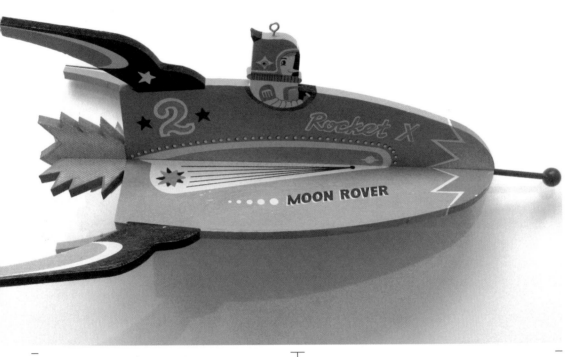

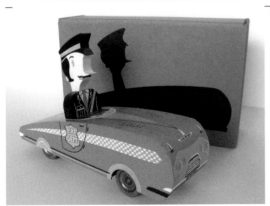

Studio MIKMIK
Saltaire, England, UK

Michael Lewis of Studio MIKMIK created this badge set and packaging. All parts were printed in two colours using a Japanese Print Gocco PG-11 B6 on Cyclus Offset stock. The *Mini Mandalas* button badge set was produced as an in-house project. Lewis' aim for the *Pattern Studies Series One: Saltaire in Stone* was to produce attractive cards highlighting the artistry of the stonemason in the World Heritage village of Saltaire, where Studio MIKMIK is based. Each card was printed in two colours using the Gocco PG-11 B6, on GF Smith 350gsm Harvest stock with matching envelopes.

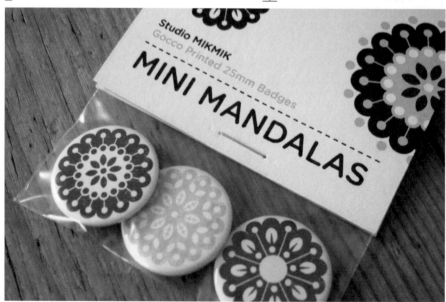

Ashkahn Studio + Co.
Redondo Beach, California, USA

The *American Badass* poster was produced by Ashkahn Studio + Co. The print is accompanied by matching greeting cards, also printed by the company. The prints were produced with two colours using water-based inks on 100lb Cougar Cover paper.

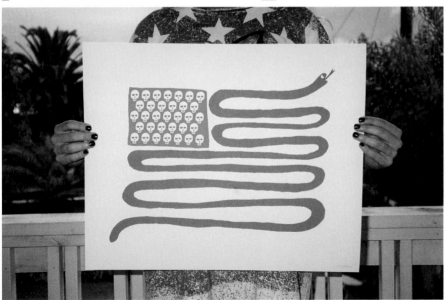

Fire Studio
Washington, DC, USA

Anthony Dihle of Fire Studio began creating the poster for the Secret Pop Band by taking lots of photos of shopping trolleys and overlaying them. He then used cyan, yellow and red to form all the colours, including the mix of green and orange in the text. The everyday images of trolleys and the Del Monte fruit sticker hint at Secret Pop Band's musical content.

The poster for Two if by Sea was created for the band's album release. Dihle compiled images and made drawings of visuals that convey a CD or album. 'I feel replacing a dinner plate with a record got the point across loud and clear, so the text itself didn't have to be quite so loud,' explains Dihle. This is a four-colour print, with a colour behind the black halftone dots to form the shading of the record and utensils.

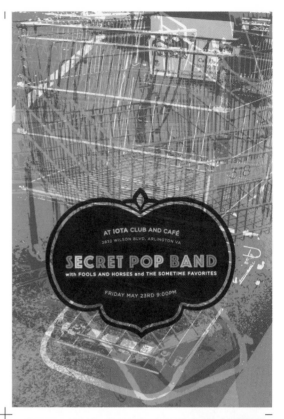

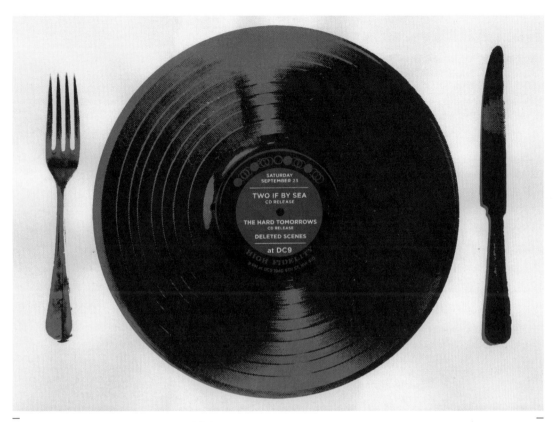

The Little Friends of Printmaking

Milwaukee, Wisconsin, USA

We're All Normal was designed by J. W. and Melissa Buchanan of the studio The Little Friends of Printmaking. The art print was inspired by the lyrics of 'The Red Telephone' by the band Love, and was created for the *Lyrics and Type* exhibition in Melbourne, Australia. Designed using Flash MX and Illustrator, it was printed by hand using three colours on white paper.

Inspired by their client's love of gold, the designers created a 'winter holiday' vibe for this poster for Art vs. Craft, the annual Milwaukee craft and arts fair. It was again printed by hand using three colours, including a metallic gold ink and a full-bleed white layer.

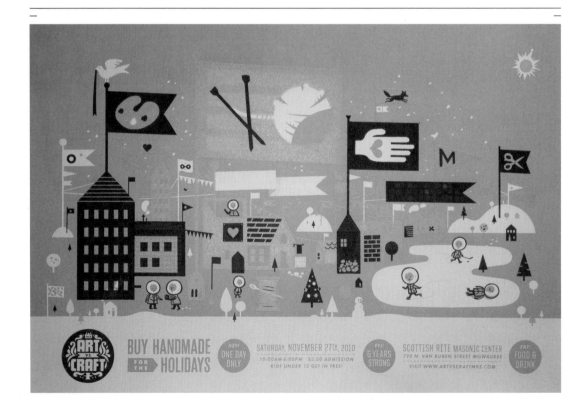

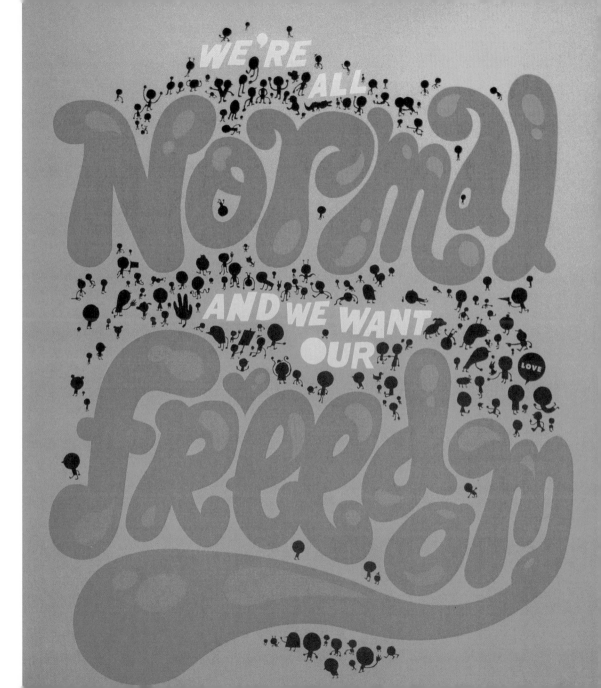

Doe Eyed
Lincoln, Nebraska, USA

Eric Nyffeler of Doe Eyed was commissioned by indie rock band The Mountain Goats to create this poster. The finished design combines an old, nostalgic photo of small-town America with hand-illustrated ghosts, stars and sun in a five-colour screenprint (CYMK+ spot white) on a heavy yellow/cream paper. The coloured poster and chunky halftones give the print a very aged and authentic look and feel that grabs the attention. Pat Oakes of Ink Tank Merch in Omaha, Nebraska, USA, printed the poster.

The indie rock band Superchunk also commissioned Doe Eyed to produce a poster for them. The goal was to make the imagery 'new wave and psychedelic'. Nyffeler combined some old scientific illustrations of the Milky Way and other celestial features with further scanned illustrations. One of the screens was printed with a split fountain (a gradient) from cyan to purple, giving the print an extra depth. Erik Hamline of Steady Print Shop Co. in Minneapolis, Minnesota, USA, printed the poster.

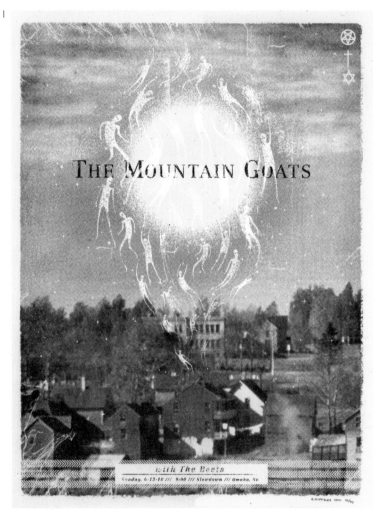

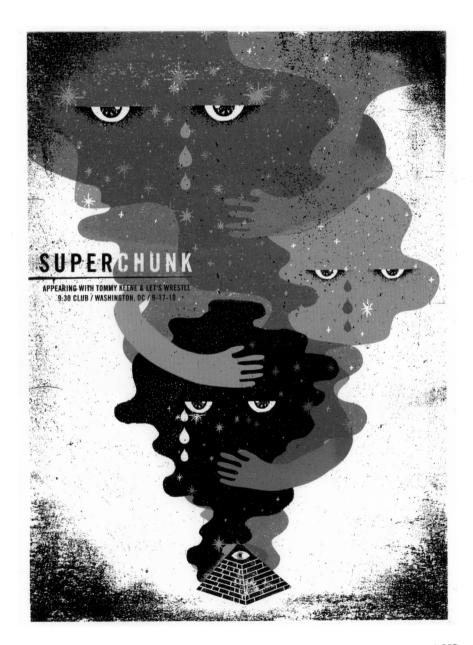

The *Rise Up Haiti* Project
Covington, Cincinnati, USA

The goal of The *Rise Up Haiti* Project was to capture the reaction of artists from northern Kentucky and Cincinnati to child slavery in Haiti. The artwork was auctioned to raise money for The Restavek Freedom Foundation, which aims to end Haitian child slavery, and get children off the streets and into schools and rehabilitation programmes.

The designs were made up of pages from Jean R. Cadet's autobiography, *Restavec: From Haitian Slave Child to Middle-Class American*. 'Each artist was given a c. 46 × 61cm (18 × 24in) piece of pine to work with,' explains Todd Lipscomb, co-creator of the event. All the elements were arranged and then wheat-pasted onto wood before being sent to the screenprinter, Mike Amann, and The BLDG in Covington, Kentucky, USA.

The featured images were supplied by Jonathan Robert Willis, a local photographer commissioned by The Restavek Foundation. Keith Neltner and Todd Lipscomb curated the event, with Lipscomb responsible for the concept and artwork layout, and Neltner producing the *Restavek Boy* illustration. Other artists involved in the project include Tommy Sheehan, Tom Post, WarnickArt, Dale Doyle, Jeff Chambers, Julie Hill, Roman Titus and Chris Dye.

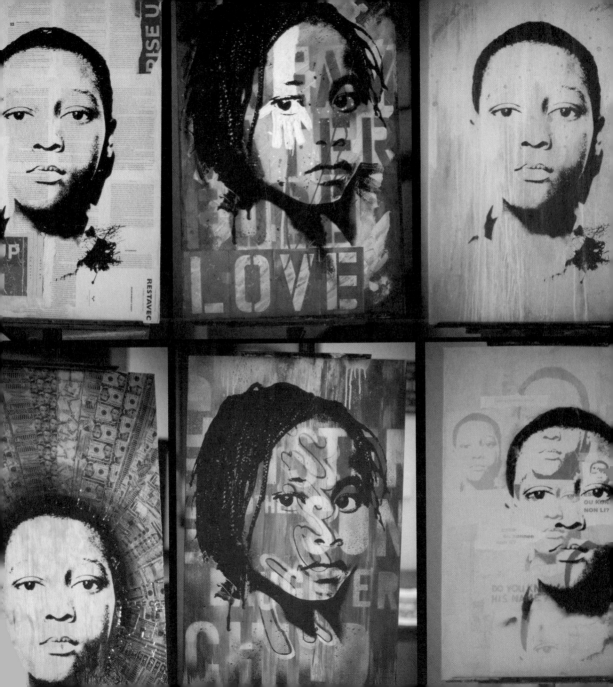

Another Example Ltd.
Hove, England, UK

With this poster Elliot Grubb – a.k.a. Another Example –
aimed to explore a new take on old Americana-style artworks.
The print itself was designed on the computer, and then most
of the colouring effects were achieved during the print process.
Two screens of colour blends going in opposite directions
were used to create the feathers. This was followed by one
extra screen of colour blending for the beak. The whole design
was then overprinted with black ink.

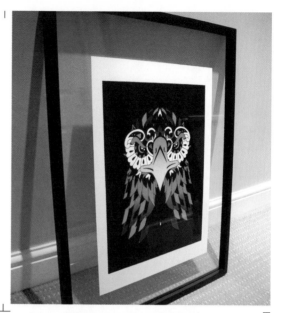

Above
Portland, Oregon, USA

Contemporary street artist Above is well known for his 'addiction' to painting and global travels. He produced this 10-layer *Hitchhiker* print on his return to the USA, after painting the original hitchhiker stencil on a wall next to a busy road in Berlin, Germany.

Above put much time and detail into his *First Love* print, and cites the 12-colour design as the most technical screenprint he has made to date. 'This print resembles the innocence of trying to grab hold and keep that first love,' he explains.

Both prints were custom embossed, signed, dated and numbered by Above, and printed on archival 250gsm Lenox 100 paper.

Sonnenzimmer
Chicago, Illinois, USA

Nadine Nakanishi and Nick Butcher of Sonnenzimmer
were commissioned to produce their *Insound 10 for 10* set
by online indie rock superstore, Insound. While each of these
posters was designed to stand alone, they also fit together
to form a larger image – a superstructure – tied together
by a common image and colours. The idea was to create
an abstract musical landscape.

The prints were produced using a mixture of four-colour
process and spot-colour printing. Using the two techniques
together allows a push and pull of visual depth and flatness
that is unique to screenprinting. The imagery was drawn
from various paintings, which were arranged on the computer.
Each poster from this series uses seven to ten colours.

Shown here are *The Pains of Being Pure at Heart (Insound
10 for 10)*, a nine-colour print, and *Broken Social Scene
(Insound 10 for 10)*, an eight-colour print. Both were printed
in an edition of 125.

THE BEING
PAINS PURE
OF AT
HEART

Jasper Goodall
London, England, UK

Illustrator Jasper Goodall created the print *Bad Bambi* for a solo exhibition. The screenprint is finished with a UV gloss varnish and printed on 250gsm Phoenix Motion paper. It was limited to an edition of 40 signed and numbered prints.

Goodall's print *Guardian of the Golden Lake,* limited to 90 signed and numbered prints, was created by printing white ink on gold foil board.

Shepard Fairey (Obey Giant Art)
Los Angeles, California, USA

Fairey's design *Hostile Takeover* was printed onto aluminium as part of his Print Matters exhibition. 'If you look at the eye on the hand, it is framed by a round American flag banner,' explains Fairey. 'The piece is a comment on US economic and cultural imperialism.'

The image is one half of a two-part piece called *Two Sides of Capitalism*. The second print shown here is called *Mujer Fatal* – Spanish for 'Deadly Woman'. The imagery of this print paints a picture of a femme fatale–style woman. Fairey's iconic OBEY star

emblem on the headpiece is reminiscent of that of the Mexican Indigenous Movement known as the 'Zapatistas', which Fairey has referenced heavily in his work. Each of the editions was printed on metal and framed.

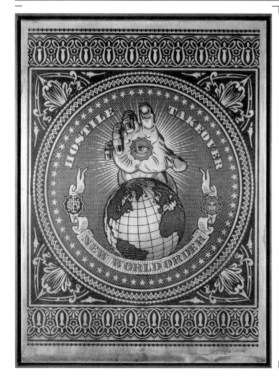

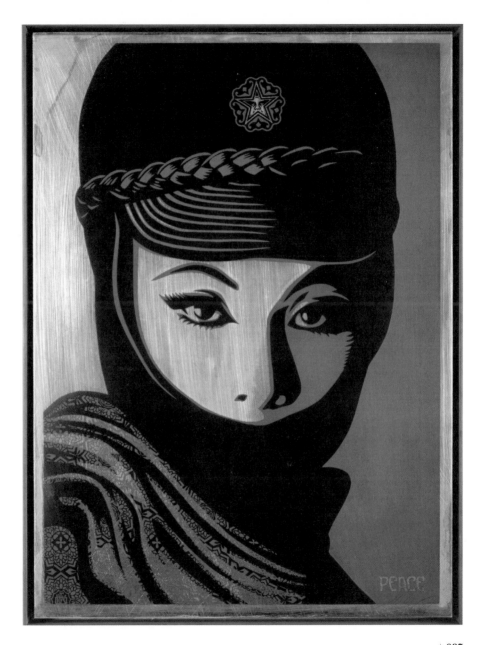

Young Monster
Chattanooga, Tennessee, USA

Art collective Young Monster created the art print shown far right. Designed by Nick DuPey and Zach Hobbs as a Halloween special edition, the poster serves a dual function. 'Hang it on your wall or cut 'em out and wear 'em. Either way, you'll have the coolest monster faces around,' explains DuPey. 'We spend a lot of time cutting up pictures and gluing them together to make weird faces and/or narratives.'

DuPey also designed the poster for the band The Dirty Lungs, using the CMYK process and overlaying the four colours – cyan, magenta, yellow and black – to emulate a full-colour image. The poster was designed for the band's show at Discoteca in Chattanooga, Tennessee.

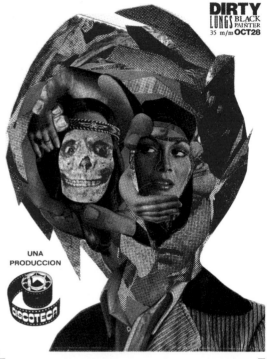

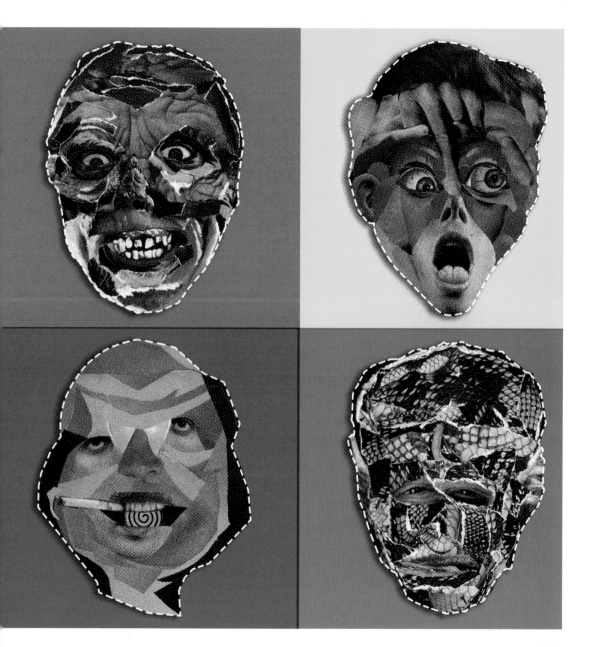

Landland

Minneapolis, Minnesota, USA

Dan Black and Jessica Seamans created these posters. Black began the print entitled *Summer Ghosts/Winter Pool Party* by drawing all six transparent overlapping layers separately by hand. He then scanned each component individually and arranged the layout in Illustrator. The poster was then printed in six colours in Landland's studio, before being signed and numbered. For the poster created for Cap'n Jazz's reunion tour, Seamans began by making watercolour paintings from aerial shots of fields, while Black drew the type. They then separated out the finished four CMYK channels, assigned halftones to each of the four process colours, and rebuilt the colour separations in Illustrator. The poster was printed in five colours (CMYK and the yellow/beige border).

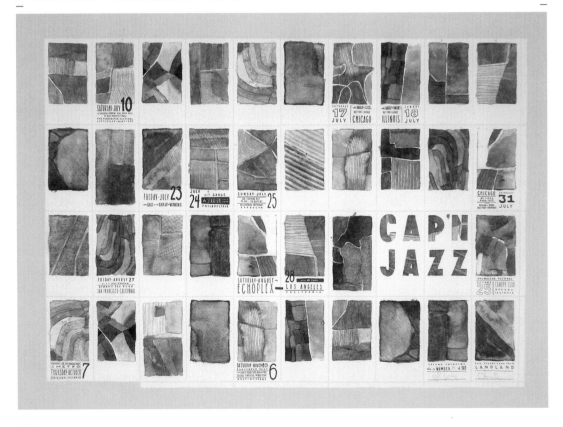

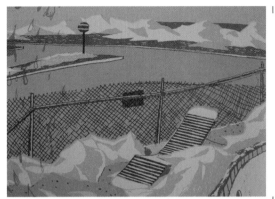

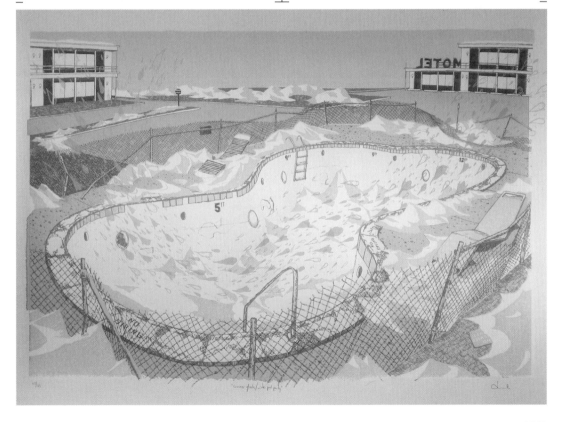

Delicious Design League
Chicago, Illinois, USA

These three posters – *Lion*, *Kudu* and *Mandrill* – were created by Billy Baumann and Jason Teegarden-Downs of Delicious Design League. The idea for these prints evolved from their desire to further explore an illustration style they had previously used for a gig poster.

'Every piece we create starts as a rough pencil drawing, and from there we use the computer, paper and pencil, ink, dirt, copy machines, found photos – whatever we need to get the look we want,' explains Baumann. 'We try not to limit ourselves to one way of executing a design – in fact, we constantly challenge ourselves to try new ways to design and illustrate.'

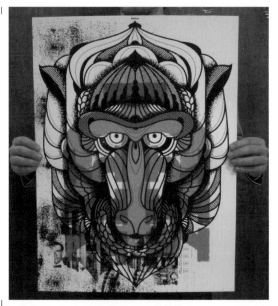

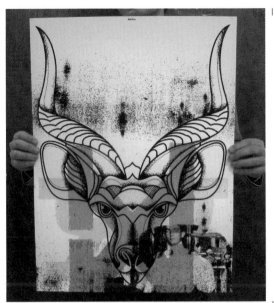

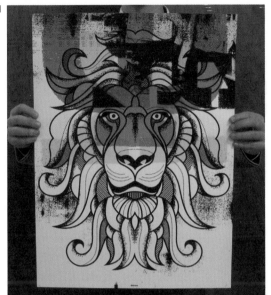

Brainstorm Print & Design
Philadelphia, Pennsylvania, USA

Atmosphere, *Earth* and *Ocean* are a set of prints designed to be a modern take on vintage educational science graphics. Pieced together from information found both online and in vintage science books, the prints were created on the computer by Brainstorm's Jason Snyder and Briana Feola.

'The poster set was not created all at the same time. *Atmosphere* was created first and initially was going to be a stand-alone print,' explains Snyder. 'After printing it and seeing the digital piece come to life, we were inspired to create more pieces in the same style to create this set.

'*Earth* came a few months later, followed by *Ocean*.' The posters were printed by hand, one colour at a time, with water-based Speedball inks, on 110lb French White Construction paper.

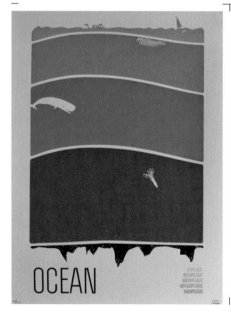

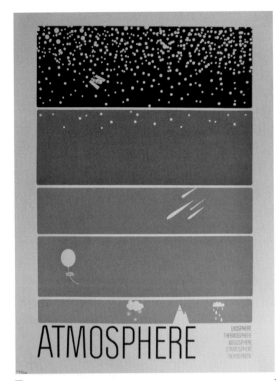

ATMOSPHERE

EXOSPHERE
THERMOSPHERE
MESOSPHERE
STRATOSPHERE
TROPOSPHERE

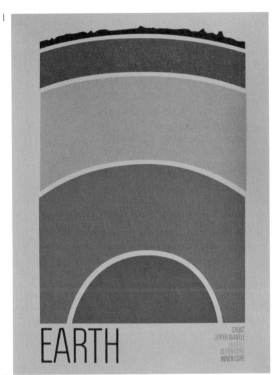

EARTH

CRUST
UPPER MANTLE
MANTLE
OUTER CORE
INNER CORE

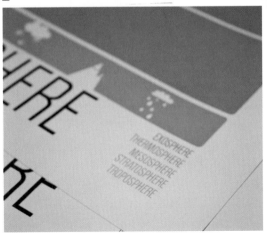

Bandito Design Co.
Columbus, Ohio, USA

Ryan Brinkerhoff of Bandito Design Co. created this *Post-er Cards* set. The cards are an accumulation of some of the illustrations and designs that Bandito Design Co. had created in the previous year. 'This project is a celebration of our first year of making things; our first birthday,' explains Brinkerhoff.

The cards were all screenprinted as one big c. 46 × 63.5cm (18 × 25in) sheet by Seizure Palace in Portland, Oregon, USA, and then trimmed and packaged neatly by Bandito Design Co. themselves.

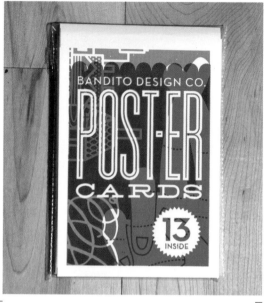

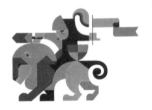
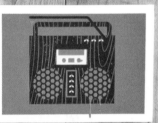
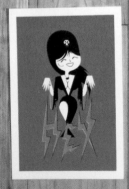
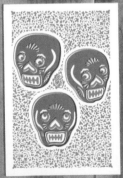
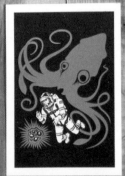
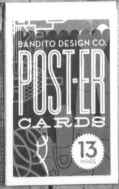

Boxbird Gallery and Studio
Hove, England, UK

Graham Carter of Boxbird Gallery and Studio in Hove, UK, designed and printed this framed, multilayered screenprint. Entitled *Ever Ready*, the piece was created for a solo exhibition at Ink-d Gallery in Brighton, UK. Carter wanted to explore the use of silk-screen methods together with laser-cutting to build up a more 3D-looking image. Working closely with the framer, Carter decided to print onto the backing board of the frame to create the background element. The middle element (the black robot) was created using laser-cut Perspex, while the foreground was printed onto the reverse side of the glass using gloss enamel, oil-based inks.

Business Class (bottom row) was created by Carter as a follow-up to two other images with similar characters, each one exploring the contrast between the exterior and interior while travelling. 'I used System 3 acrylic inks with around one-fifth to one-quarter mix of gel medium – more for extra transparency,' explains Carter. 'I find it suits my work better to print onto a smoother, heavy-weight paper – around 300gsm – such as Fabriano Artistico or Somerset Velvet.'

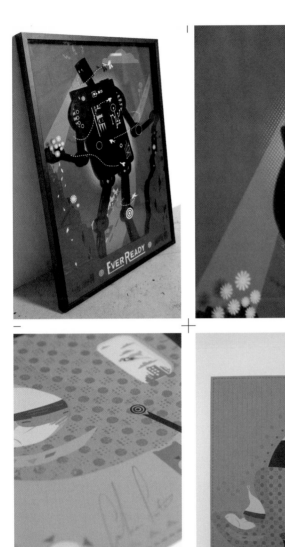

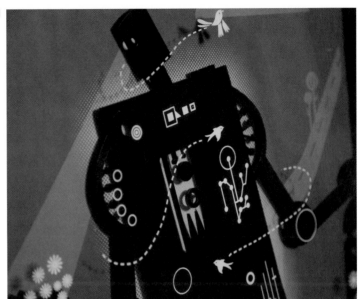

Luke Whittaker
London, England, UK

Luke Whittaker, of London animation and videogames studio State of Play, created these prints as a way of working stories into pictures and reconnecting with hand-made aesthetics. For this print, entitled *I can see us sitting here*

in many years to come, Whittaker was inspired by the idea of taking back the signs we see around us (so often advertisements or warning signs, impersonal and hectoring), and making them more personal.

Damien Tran
Berlin, Germany

Screenprint artist Damien Tran created these *Robot* posters after a friend asked him to contribute to a book on the theme 'metal'. He made the basic collages from technical drawings and old catalogues. 'I didn't want to use the computer too much,' explains Tran, 'so I printed out the type and graphic elements to create the layout directly at the light table.'

Tran printed the posters on a thin aquarelle paper, as he likes the poorly printed and slightly different look this gives to each one.

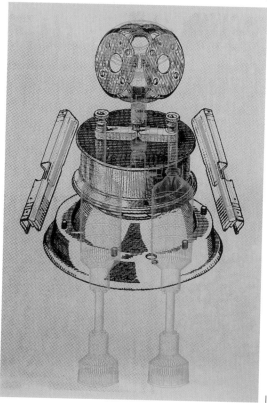

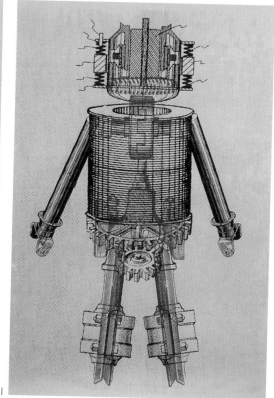

Douze Design Studio

Dresden, Germany

These multicoloured images show *Squeegeedragger
'The Old Squeegee'*, a piece created by Lars P. Krause
of Douze Design Studio for the Squeegeedragger Group
Show at Galerie auf Halb Acht in Hamburg, Germany.
Krause designed a squeegee in action within the framed
piece. The background was hand coloured and the lettering
was screenprinted on top. The actual squeegee was perforated
with a saw and coloured with Krause's fingerprints.

Krause was asked by the American Poster Institute
to create the official poster for Flatstock Europe 5, held
at the Reeperbahn Festival in Hamburg, Germany.
'The festival was held near the harbour with many pubs,
bars and the red-light district, which is why I used a very
tattooed sailor girl in a muscle pose for the design,' explains
Krause. The poster was designed in Illustrator, and then
hand printed in five colours by Krause himself.

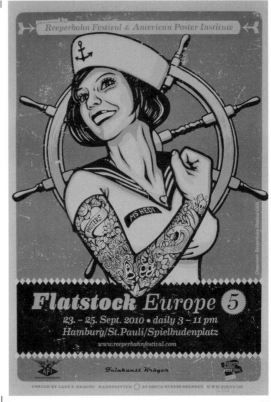

Kid Acne
Sheffield, England, UK

These images show the collaborative screenprint/*lambe-lambe* prints from Kid Acne's *Stabby Women* series. The posters were printed at Grafica Fidalga, São Paulo, Brazil, one of the last surviving print shops using the traditional hand-carved woodblock press. The days of the *lambe-lambe* or *lick-lick* (referencing the way in which the prints were posted in the city streets) are sadly numbered. Choque Cultural Gallery has been working with Grafica Fidalga and international artists to help sustain traditional woodblock printing and keep a dying art alive. The *Stabby Women* series also includes the screenprinted wheat-pastes in the streets of São Paulo, London, Paris, New York and Barcelona. Kid Acne went on to produce this *Stabby Women* fanzine, which is screenprinted by hand.

'Set free to invade São Paulo, this band of female warriors has grown in power to occupy the nooks and crannies of cities worldwide,' he explains.

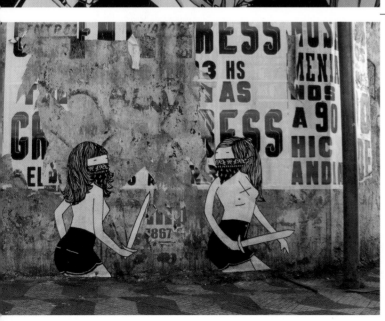

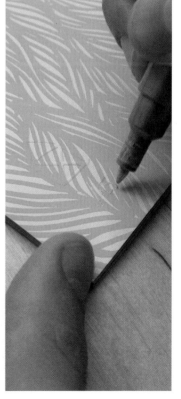

Electric Company
New York, New York, USA

Electric Company created these two prints as part of a series inspired by Eric W. Sanderson's book, *Mannahatta*. '*The Island of Mannahatta* serves to create an attractive visual dichotomy between nature and the creations of man,' explains Brett Middleton, co-owner of Electric Company alongside printer David Toto. The Chrysler Building is overlayed on a setting common to the mid-Atlantic region of the USA, showing what might have existed in the place of current-day midtown Manhattan.

The second in the series is called *Jazirat al-Arab*, which translates as 'The Arabian Peninsula'. It was designed to evoke thought about the world's tallest building, the Burj Khalifa in Dubai, and its close proximity to the surrounding desert. The background works as an homage to how the area once looked. The prints were created on c. 56 × 76cm (22 × 30in) Stonehenge Warm White paper, using TW Graphics water-based ink. The project used five colours, including CMYK and a grey underbase for the shadows.

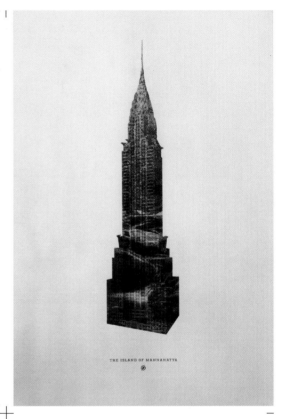

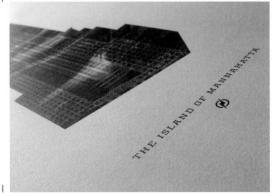

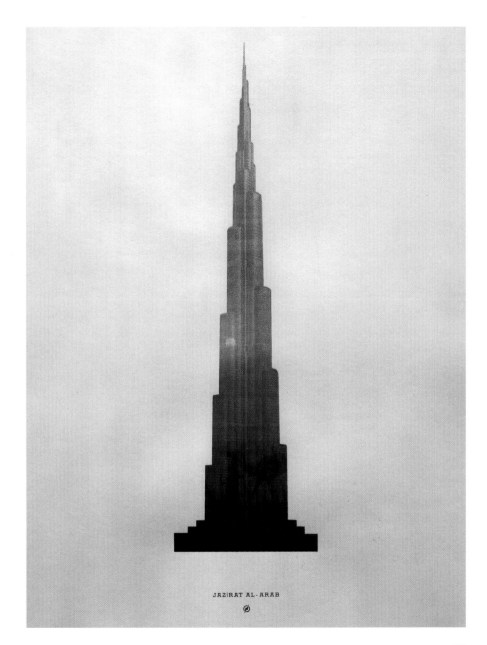

JAZIRAT AL-ARAB

Design des Troy
San Francisco, California, USA

Design des Troy is husband-and-wife team Owen and
Samantha Troy. They produce their own line of hand-printed
greeting cards, such as the selection shown here. Owen
and Samantha design the cards collaboratively using
a combination of digital and hand-drawn elements, before
printing them using a large-scale Japanese Print Gocco.

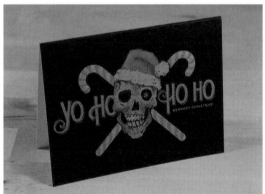

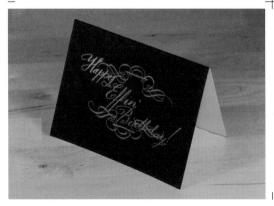

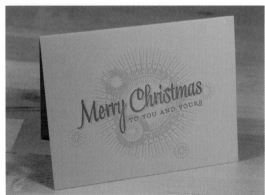

The Comet Substance
Zurich, Switzerland

Ronny Hunger of The Comet Substance created this poster
as tour merchandise for the band Yakari. Hunger started by
researching images depicting the correct method of holding
pets. 'I picked the alligator, because for me it is an unusual
pet and it's kind of strange to see a boy holding one,' Hunger
explains. 'I like to create something weird and funny in
my work.' After searching for pictures in different books,
magazines and online, Hunger cut, arranged and scanned
the elements before finding the type and defining the colour
on the computer. The poster was printed on white uncoated
natural paper, in three colours (black, blue and cream) using
water-based ink.

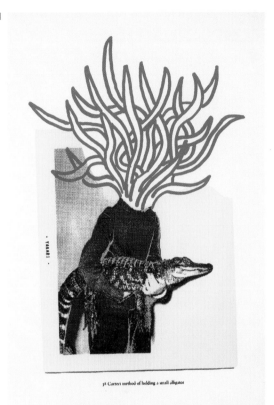

38 Correct method of holding a small alligator

Adam Turman
Minneapolis, Minnesota, USA

Illustrator and screenprinter Adam Turman was inspired to create this beer print by the famous Grain Belt Beer sign, just off the Hennepin Avenue Bridge on the Mississippi River in north-east Minneapolis, USA. For this piece Turman photographed the sign for reference before using Photoshop to manipulate the image to make a scale mock-up. He then redrew the image, combining the diagonal-stripe and wheat-grain elements from Grain Belt Beer's branding. The final composition is printed in three colours on 100lb Cougar Natural Cover stock.

Turman also designed and created this shark print. 'It was inspired by *Shark Week* and various TV shows where sharks fly out of the water to rock the world of sea lions,' explains Turman. It was printed in three shades of blue on 100lb French Nightshift Blue Construction paper.

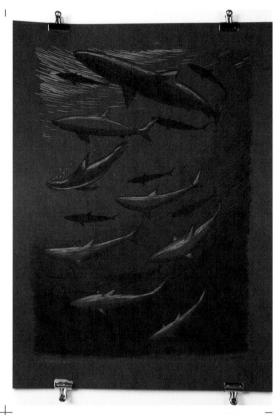

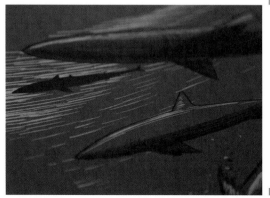

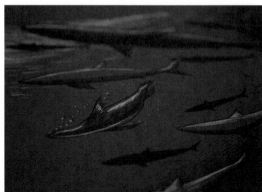

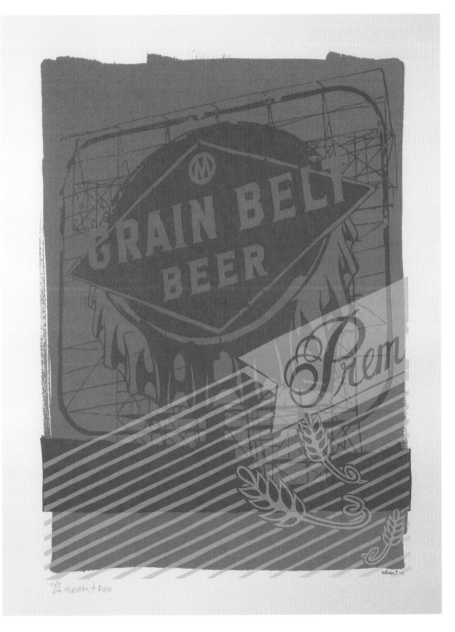

Atelier Deux–Mille

Toulouse, France

Nicolas Delpech of design studio Atelier Deux-Mille created these art prints. 'I'm inspired by kinetic and geometrical art like Agam Yaacov's work, and psychedelic designers like Victor Moscoso,' explains Delpech. 'I tried to reinterpret this imagery in generating the work with new computer tools combined with a traditional way of printing. There is a specific printing challenge by hijacking the classic use of CMYK colours.' *Form is Emptiness, Emptiness is Form V* (shown right) is printed in three colours using the CMYK process, deliberately leaving out the black ink layer to create a particular contrast. Delpech went on to use a dry embossing plate to create impressions in the middle of the print.

Enjoy Chaos (far right) was created by the same process, this time using only two colours (cyan and magenta) to achieve the desired effect. Both prints were created using Photoshop and Illustrator, with Delpech collaborating with Eugénie Babion, Lucas Faudeux and Benjamin Stoop, the other members of the Atelier Deux-Mille studio.

Greg Pizzoli
Philadelphia, Pennsylvania, USA

The art print *Toot-a-Loot* was created by illustrator Greg Pizzoli, who drew the illustration in pencil and ink, and then scanned and redrew it in Photoshop with a Wacom graphics tablet. It was printed in two colours on white cover stock.

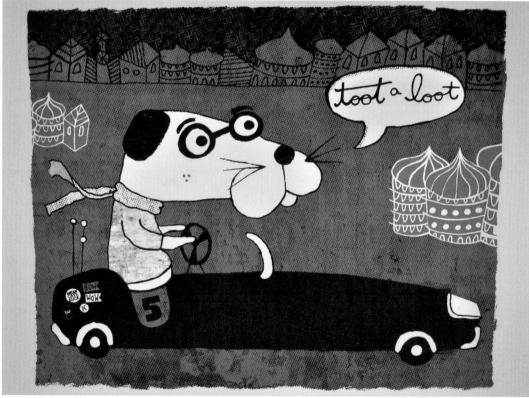

Nick Agin
New York, New York, USA

Graphic designer Nick Agin produced these two typographic prints, entitled *Loves me/Loves me not*, from the French game Effeuiller la Marguerite. 'I thought that this phrase would lend itself well to a diptych format,' explains Agin. He drew the initial forms in pen and ink, then scanned and rescaled them to fit the final image area. The final screenprints are two colours on French Smart White Cover stock.

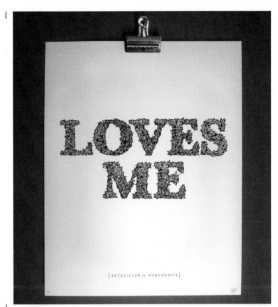

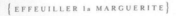

AKA Corleone
Lisbon, Portugal

Pedro Campiche – AKA Corleone –
produced his poster series, *This Is Not
Graffiti,* for a solo show at the Montana
Shop & Gallery in Lisbon, Portugal.
An illustrator with a graffiti background,
he aimed to create a six-step guide for
graffiti writers entering the art world.
'I used clichéd graffiti background
quotes and distorted them with my
personal experience and dark humour
through typography and illustration,'
he explains.

Printed in three colours using oil-based
inks, on 220gsm Fabriano 60-percent
cotton paper, each of the six steps was
created in a limited edition of eight
signed and numbered prints.

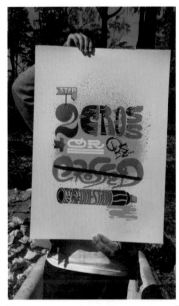
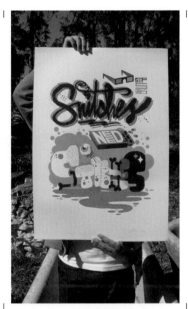
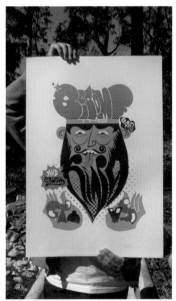

Ork Posters

Chicago, Illinois, USA

Ork Posters was born when founder Jenny Beorkrem designed her original city neighbourhood poster, *Chicago*. Since then she has expanded her neighbourhood range and ventured into a new anatomical range. 'It generally starts with a Google map and a city's neighbourhood map,' Beorkrem says of her design process. 'Questions are asked of neighbourhood councils, residents and a variety of other "experts". In the case of the anatomy prints, I reference a medical diagram.'

The *Seattle Neighborhood* poster was printed with Speedball Acrylic inks in four colours on 80lb French Oatmeal cover paper, 100-percent recycled stock. *Right Brained* is printed with Speedball Acrylic inks in four colours on 80lb French Paver Red Construction cover paper, 100-percent recycled stock.

Gotta Have Heart is printed with Speedball Acrylic inks in four colours on 80lb French Cement Green Construction cover paper, 100-percent recycled stock. Steve Walters and Erin Armstrong printed the posters on a semi-auto press at Screwball Press in Chicago, USA.

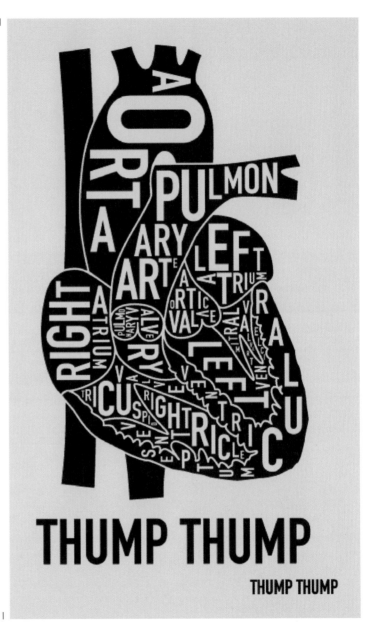

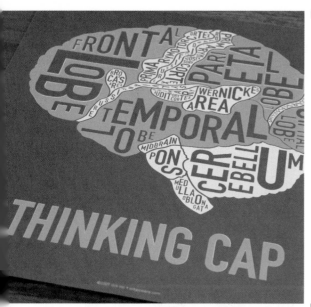

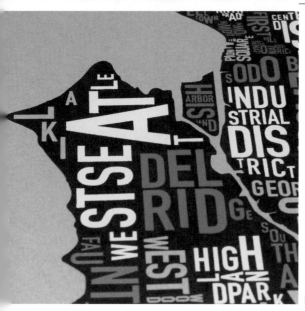

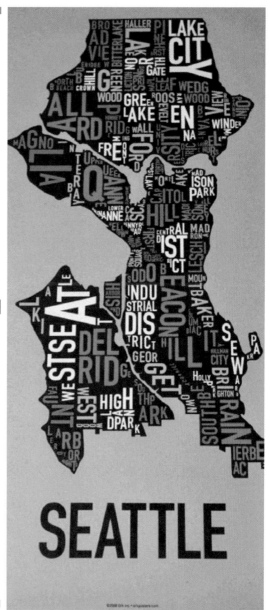

Luke Drozd

London, England, UK

Luke Drozd designed this poster for indie band Spoon's London show. 'I think of Spoon as having a mature and intelligent fan base, so I wanted something that would appeal to them,' he explains. With a nod to singer Britt Daniel's emotive lyrics and the title of the band's previous album, *Gimme Fiction*, Drozd chose to rework the classic Penguin paperback cover design.

Drozd created his initial drawings in pencil for the black top layer and brush and ink for the background, before digitally scanning the images and adding colour in Photoshop. The final print was produced with oil-based inks on 240gsm Taurus uncoated paper.

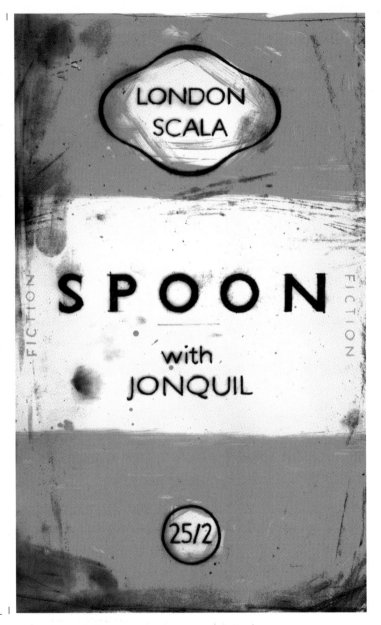

Transmission
Brighton, England, UK

He's Not the Messiah was designed by Transmission for Show Below, an art exhibition featuring the work of printmakers, illustrators and graphic designers. 'Our inspiration comes from all aspects of contemporary culture, including music, comedy catchphrases and lines from cult films,' explains Stuart Tolley, Transmission's founder. The numbered and signed poster, inspired by the movie *Life of Brian*, was screenprinted on 300gsm white paper using a gradient technique from cyan to orange.

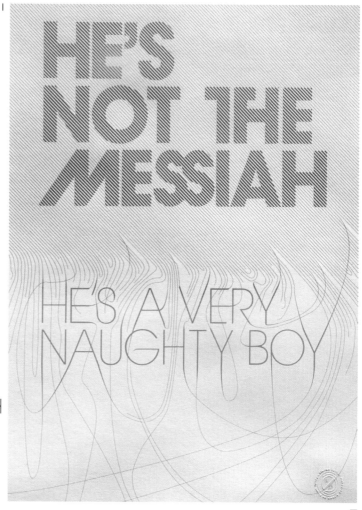

Will Scobie

Brighton, England, UK

Will Scobie bases his work around continuous line, strong composition and graphic simplicity. Scobie says: 'I start off by drawing ideas, working out composition and format. I then scan my solid pencil sketch, work up the vector artwork, and decide how many colours to use. I like to use primary acrylic colours and to print on a nice heavy cartridge paper stock.'

On your bike! (below) is a promotional piece, *Go!* (right) is a limited-edition print created for sale at Zookimono studio, France, and *Onslow the Octopus-man* is a limited-edition print created for the *FreakShow Illlustration* exhibition.

—

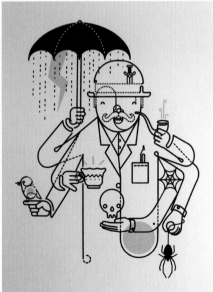

Littleclouds
Hong Kong, China

Alison Tang of Littleclouds makes bold and fun hand-made objects, such as these pincushions. The pincushion watch and 'home sweet home' ring were first drawn in Illustrator, then screenprinted onto their respective materials – calico in the case of the watch and stiffened felt for the ring. They were then cut, stuffed and hand sewn, before being glued onto either a ring or an adjustable strap.

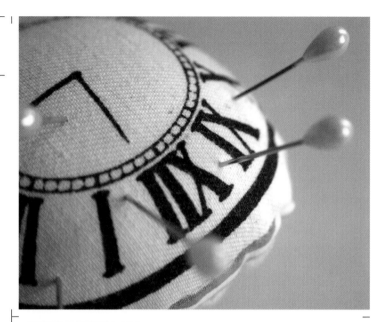

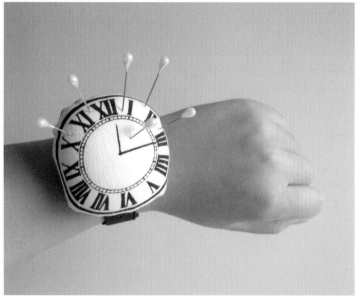

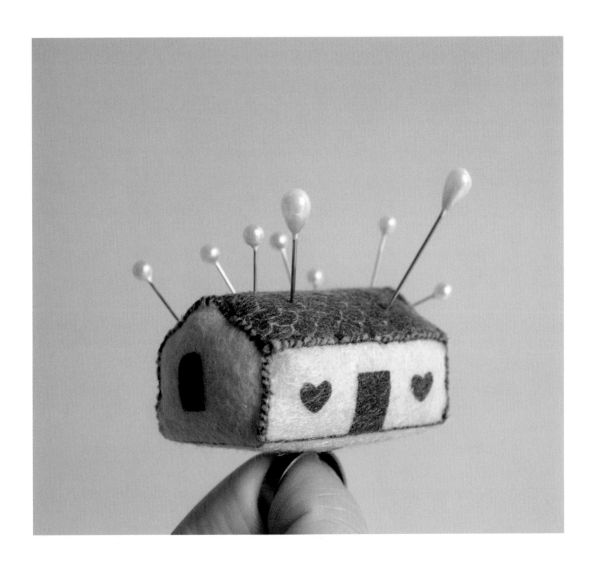

Patent Pending Industries
Seattle, Washington, USA

These posters were designed by Jesse LeDoux and Jeff Kleinsmith of Patent Pending Industries. Kleinsmith designed the poster shown right for the band Minus the Bear. 'I began with a very loose sketch,' he explains, 'and purposely detached the type from the images. I then spent a long time with the scanner and computer to create the images and layout.' The Head Light Hotel printed the poster on 100lb Lynx cover stock, using Nazdar inks.

The poster below was commissioned for a screening of Stanley Kubrick's classic movie *The Shining*, at the ski lodge where most of it was filmed. 'My goal was to capture the fear, confusion and descent into madness of Jack Nicholson's character,' explains Kleinsmith. 'I focused on the labyrinth scene but my version has Nicholson's character symbolically walled in.' The design uses three levels of grey to give it added depth, and was printed by D&L Screenprinting, Seattle, on 100lb Lynx cover stock, using Nazdar inks in five separate colours. All photography is by Toby Keane.

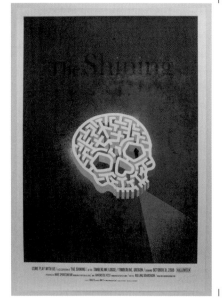

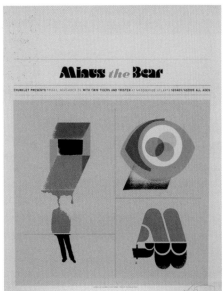

Heiko Windisch

Eppelheim, Germany

Heiko Windisch designed these two prints, *Hellbent* and *Skull Island*, for Print Club London, UK. *Hellbent* was produced for Print Club's annual *Blisters on My Fingers* show, while *Skull Island* was one of the first prints to be sold in Print Club's Brick Lane store. Both were printed by Print Club and photographed by Kassie Borreson of Hausfrau Fotografie.

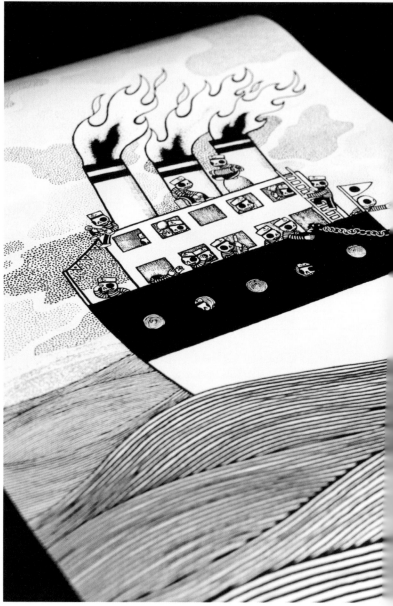

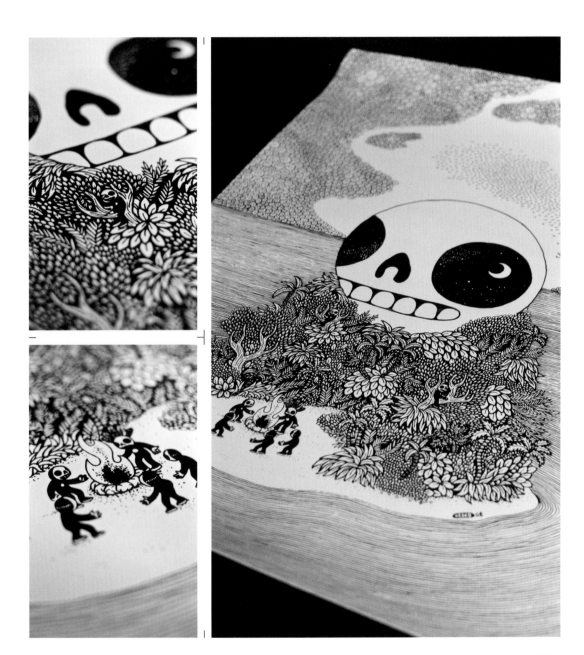

If'n Books + Marks

Providence, Rhode Island, USA

The Cancerpants Journal, complete with *The Cancerpants Superfuntime Kit*, is a unique take on journals for cancer sufferers. Artist Jesse LeDoux was asked to create the illustration depicting a quirky character opening up and making a cancerous black cloud leave forever. For screenprinting the covers, Alec Thibodeau used two different-coloured acrylic inks on Davey board. The included kit contains a pencil, tattoo, sticker, postcard and journal tips as an inspirational bonus. 'Cancer better be wearing double-underwear 'cause I'm gonna kick its ass!' is printed on the 10cm (4in) pencil with eraser.

'A close friend was enduring extremely invasive treatment for melanoma. I wanted to create something funny and irreverent, yet also sophisticated enough for the gravity of the issue, and thus the journal for loved ones with cancer was born,' explains Deb Dormody, founder of If'n Books + Marks. 'One dollar from every book sold goes to a variety of cancer-related non-profits.'

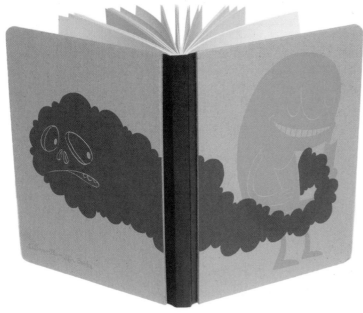

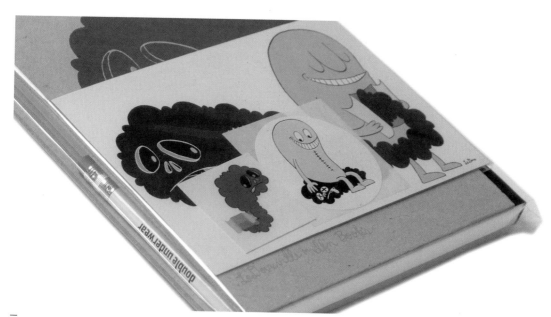

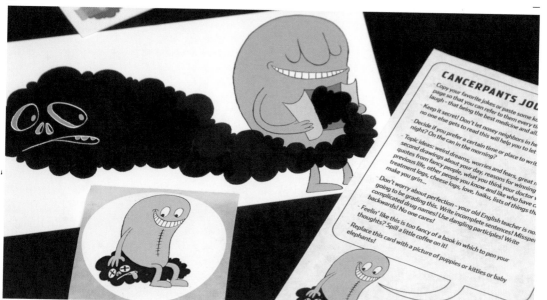

Zookimono
Lannepax, France

Zookimono, set up by husband-and-wife team Chris and Yudit Elliott, collaborates with independent graphic designers to turn their artwork into original posters and iPod, iPhone and laptop skins. The screenprint studio specialises in small limited-edition runs, including British illustrator Gemma Correll's *Sweet Treats* (iPhone), and Finnish illustrator Sac Magique's *Serpentine Days* (iPod and laptop).

To print the skins – on high-quality vinyl – Zookimono uses custom-blended, Pantone-matched vinyl inks. The printed skins are cut to different templates, depending on what they are for, and then coated with a clear varnish for durability and protection – which also gives the finished skins a surprisingly warm and waxy feel.

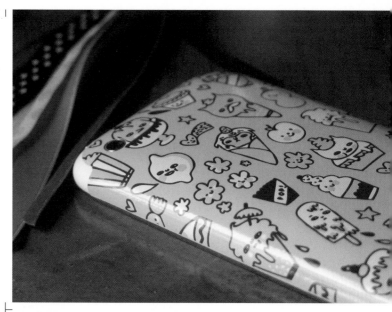

The Silent Giants

Ferndale, Michigan, USA

Christopher Everhart and Ed Knight – The Silent Giants – took great care when designing their personal business cards. 'Most business cards you just throw in your pocket or wallet,' explains Everhart. 'We wanted people to look twice at our cards, and want to keep them.' This was the first ever piece The Silent Giants printed in their studio, using metallic gold ink and 100lb French Brick Red Construction paper.

DNML

Minneapolis, Minnesota, USA

Daniel Luedtke, a.k.a. DNML, is a self-taught printmaker, artist and musician. His brightly coloured, graphically bold prints, installations and public work pair geometric abstraction with absurdist figurative elements that are often inspired by feminist politics, folk art and kitsch.

Luedtke created the print *Brute Heart*, right, as a promotional poster for his own band, Gay Beast. His aim was to design a poster that looked like a Halloween rave advertisement. *Flocked: A Wallpaper Project Poster*, below, was created in collaboration with Jessica Seamans of Landland (see pp. 100–101).

Gary Taxali
Toronto, Ontario, Canada

Gary Taxali created *Toy-Car* for his solo show, *Hindi Love Song*, at the Jonathan LeVine Gallery in New York, USA. Starting life as a small drawing, the piece was eventually printed on an old found steel street sign. Taxali decided to use lead-based inks to get the depth he wanted. 'Because the steel was so old and weathered it had a wonderful texture, which I was pleased to see show through in the final art,' he explains.

Wallop was created for Taxali's *Flop House Rules* solo show at the Iguapop Gallery in Barcelona, Spain. Using a Print Gocco B5, Taxali printed his characters on single pages of found paper and then taped them all together to create one large image. He finished the piece by scrawling various thoughts and images in pen and pencil, adding a few personalised rubber stamps of some of his characters as a final touch.

All images © Gary Taxali

Mis Nopales
Downey, California, USA

Jose Pulido creates illustrations and characters inspired by South American and Mexican cultures. By using a Print Gocco PG-5, Pulido creates a uniquely different print each time. All his prints measure c. 13 × 18cm (5 × 7in) and are printed on Coventry Rag paper.

Wertzateria
Oakland, California, USA

Illustrator Michael Wertz created *Haiti Hand* for The Haiti Poster Project, a collaboration of artists and designers around the world, benefitting victims of the earthquake in Haiti. 'I used Haitian/voodoo protection symbols as the basis of this image,' explains Wertz. 'At first I was spooked to use the symbols, but then a friend told me if I drew them properly they would protect my home.' The design was printed in two-colour transparent inks, overlayed to make the third colour, by Nat Swope at the Bloom Screen Printing Co. in Oakland, USA.

Iain Hector
London, England, UK

Iain Hector created these three limited-edition screenprints – *Flamenguin, Toucanzee* and *Puffalo* – as part of an ongoing series of animal hybrids. 'First I decide on a name that I think works – this is as important as the finished visual,' says Hector. 'Then I decide which way round to combine the two animals, often using found imagery, and create my initial computer sketches in Illustrator.' For each print Hector simplifies his final image and limits the number of colours to produce the screenprint artwork. He printed all three editions himself on 300gsm Canford stock.

1/35 I. HECTOR

1/35

I. HECTOR

Haniboi Co. Ltd.
London, England, UK

Han Lee of Haniboi Co. created these posters as part of the *Thingamabob* series. His goal was to create a series of objects that simplified complicated feelings or confusing situations. 'Originally my illustrations were mostly characters,' explains Lee, 'but after I'd researched lots of cold objects I became interested in the relationship between humans and machines.'

The posters were printed using System 3 acrylic ink on 350gsm stock.

Egg Cup Soldier
London, England, UK

Caspar Williamson of design studio Flyingmachines, and Hassanayn Rauf and Tom Price of web-design agency Mustard Up, formed Egg Cup Soldier to fulfil the demand for their sell-out designs. *Cat, Sank, Cease* is one of a series of posters playing with the idea of language-learning techniques and mnemonics. Williamson created the background by scanning cracked paint and separating the layers in Photoshop to make a texture. The background is printed in dark teal blue ink, with the type and imagery printed on top in black gloss ink.

The poster *Lefty Loosey* is designed to evoke 1920s advertisements for pharmaceuticals and household goods. Williamson printed both posters on 250gsm Southbank Smooth stock at Print Club London, UK.

LEFTY LOOSEY RIGHTY TIGHTY

Rob Ryan
London, England, UK

To create these prints, papercut artist Rob Ryan drew the initial images on paper and handcut the design with a scalpel to make a stencil. He then coloured the backgrounds with spray paint before using the paper stencil to expose the screen. All the prints use non-toxic, water-based inks, and are printed on Heritage Woodfree paper.

Ryan produces all his work in his screenprinting studio, The Mangel, in Bethnal Green, UK, which is built and equipped from secondhand finds. The studio also has a kiln where Ryan fires his own screenprinted ceramics.

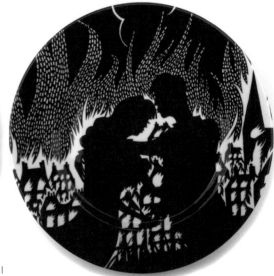

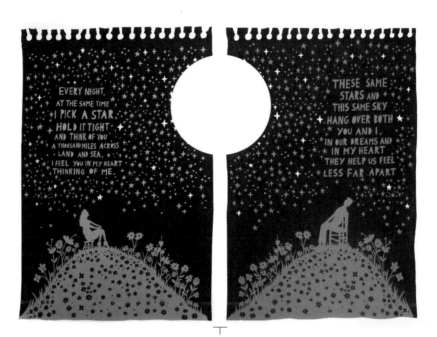

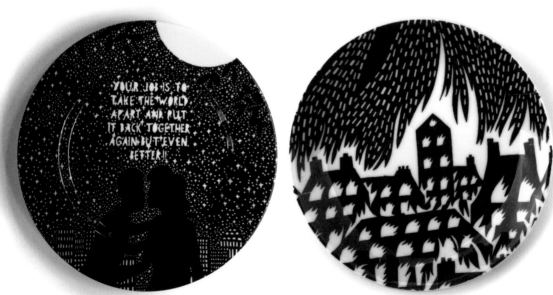

James Joyce
London, England, UK

Designer and illustrator James Joyce created *Oh No* for *Wild Fantasies*, an exhibition at StolenSpace Gallery, London, curated by Don't Panic. The edition of 50 signed and numbered prints was screenprinted by hand with fluorescent water-based inks.

Joyce created *Truth Is* for the Multiplied Art Fair at Christie's, London, curated by Concrete Hermit. The design was printed using oil-based inks for strong, lasting colour. *This This This and This* was created for a solo exhibition of Joyce's work at Kemistry Gallery, London, entitled *Drawings and Other Objects*. The edition of 25 signed and numbered prints was produced using red and yellow inks, on 270gsm Colorplan stock.

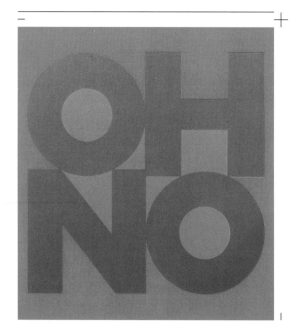

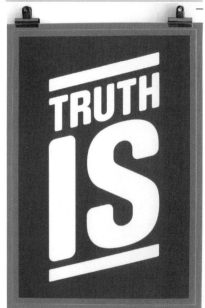

Peter Stitson
London, England, UK

Peter Stitson, former art director of *Dazed & Confused* magazine, produced *Instant Karma We All Shine On* for the *Blisters Blackout* exhibition at Print Club London, UK. An edition of 50, Stitson created the two-colour design digitally, using a typeface he designed himself and glow-in-the-dark ink for one of the colours, to show up during the 'blackout' periods that occurred throughout the exhibition's opening night.

The two prints entitled *Making It Up As We Go Along* were produced in editions of 10 (pink/black) and 50 (green/black) for sale at Print Club London. The design was originally created for the cover of *GUM* magazine (Issue 1).

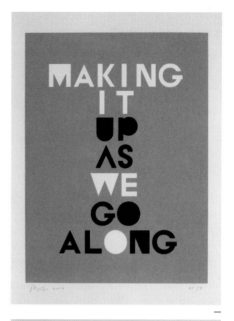

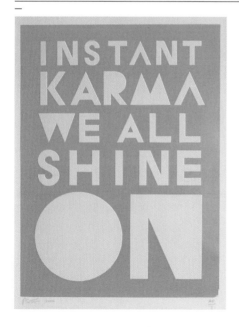

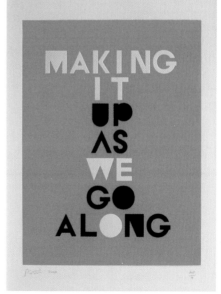

Tom Rowe
London, England, UK

Illustrator Tom Rowe produces highly detailed prints inspired by retro analogue equipment and old recording machinery. His *Big Betsy* poster (right) is based on an illustration commissioned by *Wired US* magazine to create a 'Google Machine'. The five-colour print has a signed edition of 50, and is printed on 380gsm Cyclus Offset stock. The paper size is B1 (100 × 71cm/39¹/₂ × 27⁷/₈in).

'My reaction to obsolescence and how quickly technology is replaced by an improved version of itself' is how Rowe explains his inspiration. *Brian* (far right) is a five-colour screenprint on 99 × 36cm (c. 39 × 14in) 380gsm Cyclus Offset paper, signed in an edition of 100.

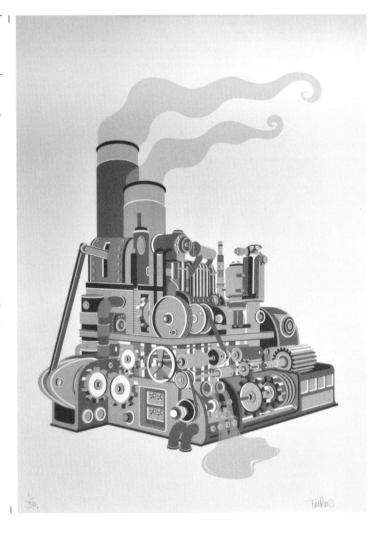

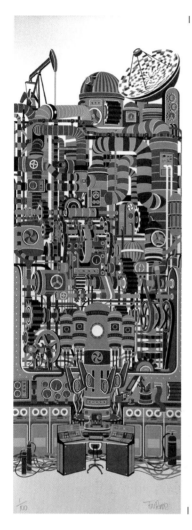

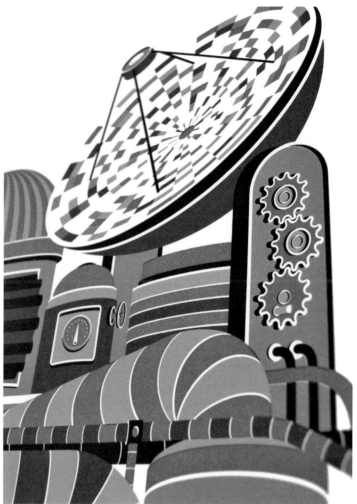

Zara Wood, a.k.a. Woody
Brighton, England, UK

Zara Wood, a.k.a. Woody, produced the print *White Night*
for her solo show, *Zara Wood: Mirror Mime* at Yorkshire
Sculpture Park, UK. Reflecting the show's title, Wood
experimented with mirrored paper, allowing it to shine
through the unprinted areas of the image. 'When viewed
from the side, the rabbit's outline glistens and appears
elusive,' explains Wood, 'and when you stand in front
of the print you're reflected in the rabbit's outline and
become part of the image.'

Wood was determined that her merchandise linked directly
to the show. For the candles, her original *Mirror Mime Twins*
drawing was duplicated and flipped, and a screen of the final
design was used to print around each candle.

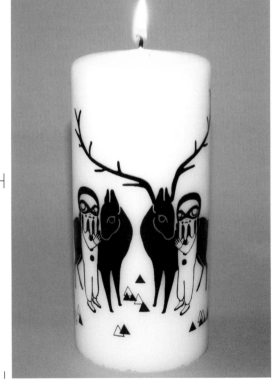

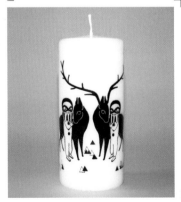

Morning Breath

New York, New York, USA

Alphabet was created by Jason Nato and Doug Cunningham of design studio Morning Breath. Originally published as a CMYK image in *Swindle* magazine, the design was then developed into a three-colour screenprint, c. 46 × 61cm (18 × 24in), and printed by Nat Swope at the Bloom Screen Printing Co. in Oakland, USA.

Morning Breath was commissioned by Seattle-based Ride Snowboards to design and print *Roach Girl* (shown far right), a four-colour poster, as an event promotion for the brand.

The artwork for *Sword Swallower* was first published in *Juxtapoz* magazine, and was later developed into a two-colour, c. 46 × 61cm (18 × 24in) screenprint, printed by Cunningham and Nato.

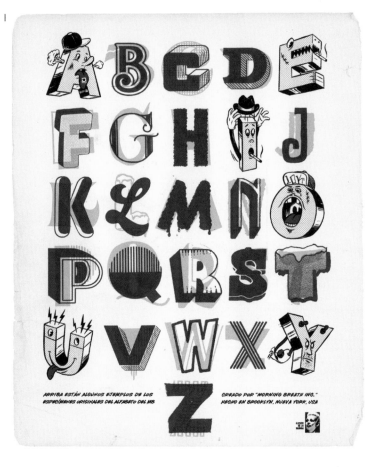

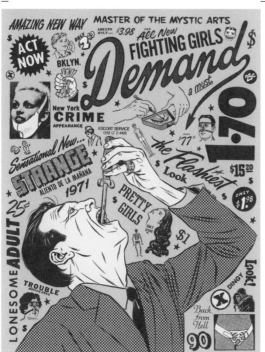

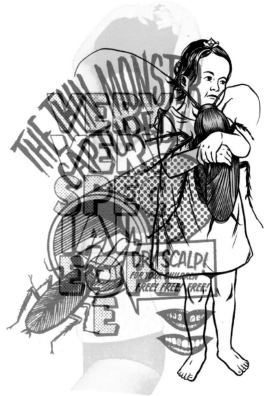

Nini Sum
Shanghai, China

When she was unable to find a studio in China that allowed her to print her own artwork, Nini Sum founded IdleBeats Screen Printing & Design in Shanghai. Her love of film director David Lynch's movies and paintings inspired this portrait (far right). 'Lots of Lynch fans from all around the world ordered the print from our site and people started asking me to draw portraits of them as well,' explains Sum.

Sum created the two art prints (right) for the Chinese Year of the Rabbit. As with all her prints, Sum first drew the illustration in pencil on paper, scanned the artwork and then coloured it in Photoshop. Sum and her IdleBeats partner Gregor Koerting produced all three prints in their studio.

Sum created the slip mats below for *A Nice Set,* a travelling exhibition, organized by *IdN* magazine, of customised slipmats designed by leading artists around the world.

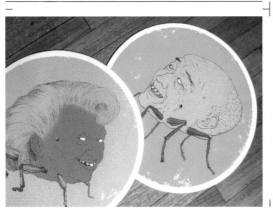

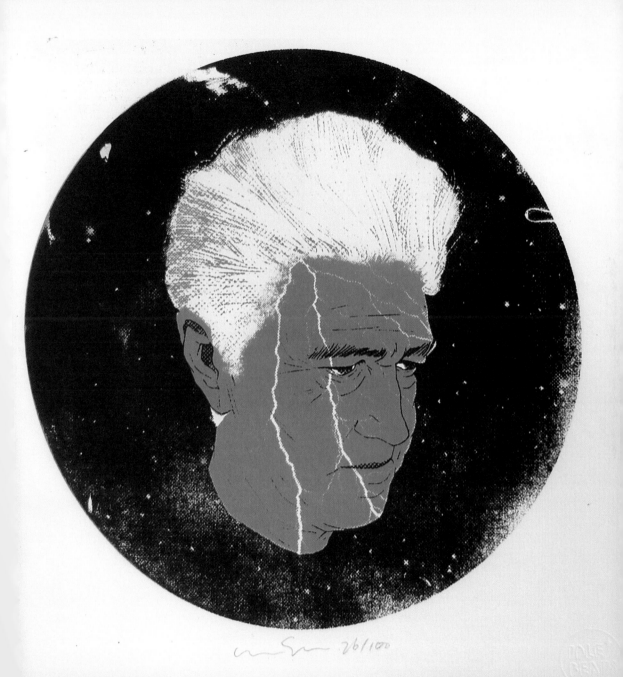

IdleBeats

Shanghai, China

Screenprint studio IdleBeats teamed up with Sub-Culture, a Shanghai-based reggae crew/promoter, to produce monthly gig posters, designed by either local or international artists. 'We have a booth at each gig to sell the posters, but people are always disappointed to find we don't sell booze!' explains IdleBeats' Nini Sum, who designed the poster for DJ Orawan and DJ Seed. *Kode 9* was designed by Christomoya and printed by IdleBeats.

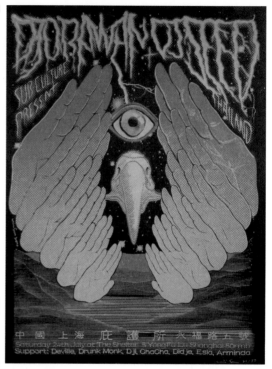

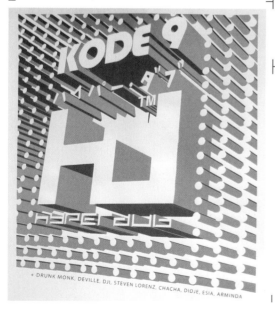

Vic Lee
London, England, UK

Illustrator Vic Lee produces Victorian-style drawings of London streets, aiming to capture their energy, bustle and independence. Although the prints appear old, when you look closely you see the cafés, shops, bars and cinemas in their modern setting.

Lee starts by finding an almost village-like street or area in central London, photographs each shop and business, and then creates an illustration on tracing paper. The final piece is hand printed using a 110-mesh screen on Somerset 100-percent cotton paper, with Daler-Rowney black acrylic water-based inks. Lee then numbers, stamps and signs each print.

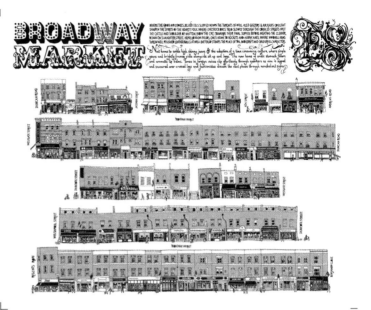

Maya Hayuk
New York, New York, USA

Maya Hayuk is a muralist, painter, photographer and printmaker based in Brooklyn, New York. She began both *Tonight Is Kind of Special* (below) and *Apocabliss* (right) by drawing each layer full size with markers on vellum, then scanning and preparing them in Photoshop. 'Several of the printed layers have a lot of base added to the inks, for some nice transparency colour play,' she explains. 'One layer is silver, which shifts with the light.' Both were printed using water-based inks on 100lb Lenox paper, with the help of Jef Scharf and Karl LaRocca at Kayrock Screenprinting, Brooklyn.

These two prints are from a series Hayuk created for London gallery and shop space Pictures On Walls. She painted directly onto translucent plastic sheeting to make positives, before exposing each layer directly onto a screen. After printing the black layer, each print was spray painted to create the star nebulas before the other layers were printed. 'The series took over a week to edition because the oil-based inks took a long time to dry,' says Hayuk. She and Sam Newbury printed the five-colour screenprint at K2 Screen, London, on 330gsm archival paper.

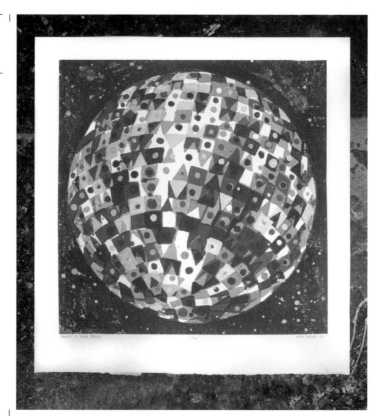

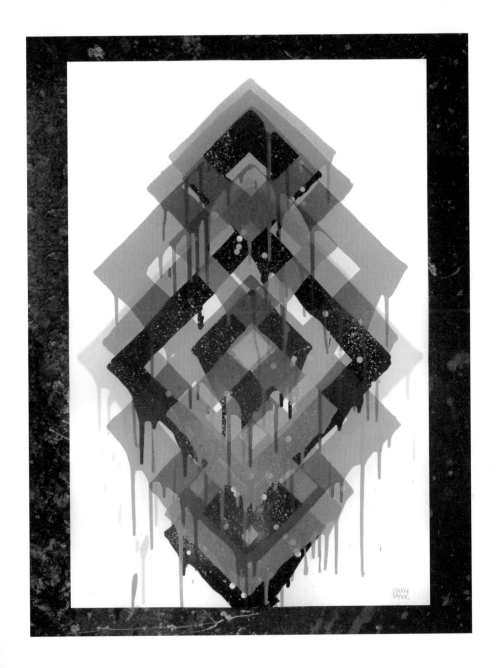

Happiness Brussels
Brussels, Belgium

Belgian communication agency Happiness Brussels teamed up with designer Anthony Burrill to create this poster. With a limited edition of 200, the posters were screenprinted with oil from the Gulf of Mexico disaster, with all benefits going to the Coalition to Restore Coastal Louisiana, a non-profit organisation dedicated to restoring the Gulf of Mexico's coastal wetlands.

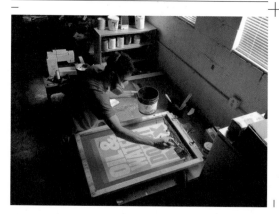

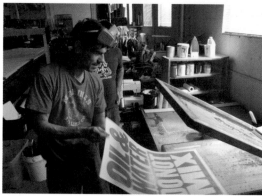

OIL & WATER DO NOT MIX

GULF OF MEXICO · 2010

Print Club London
London, England, UK

Fred Higginson of Print Club London printed his *Butterfly Army* using a technique called colour blending – merging several colours in one pull, resulting in gradients and rainbow effects. With every pass of the squeegee, the colours blend even more. '*Butterfly Army* is about things being catalogued, ordered and beautiful,' explains Higginson. 'Because the ink is continually merging, it makes each butterfly in the whole edition unique.' The posters are printed on 220gsm Fabriano 4 paper, using Neptune water-based inks.

Rose Stollard, also of Print Club London, produced this Ozzy poster for the screenprinting studio's annual *Blisters on My Fingers* exhibition. 'This is a Futurama guitar given to me by a friend of my Dad's,' explains Stollard. 'As he handed it over, he told me it used to belong to his buddy who played in a band that was to become Black Sabbath.'

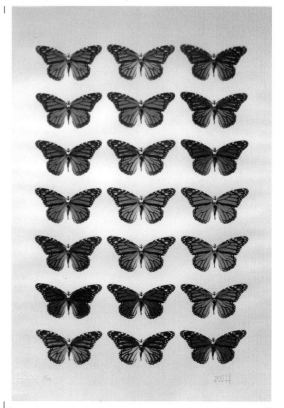

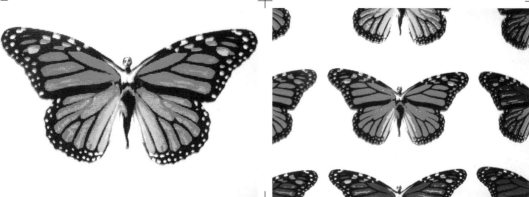

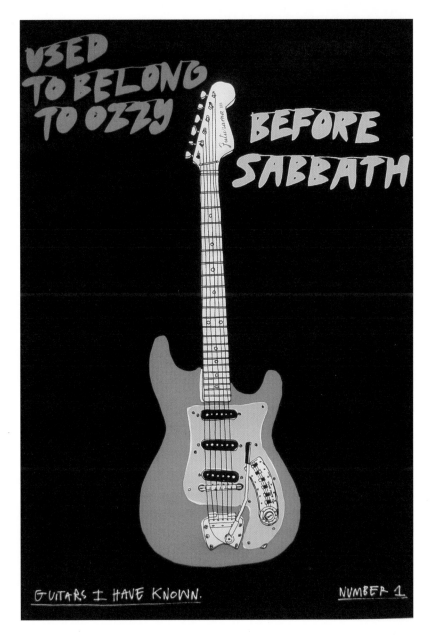

Handwash Studio
London, England, UK

Created by Yann Brien of Handwash Studio, *4×4* (right and below right) is part of a series exploring the use of lines to build modular structures and generate a visual context. 'The usual points of reference, such as distance and volume, shift and dissolve to create a unique experience for each viewer,' explains Brien. The edition of 15 posters was printed on 300gsm Somerset Velvet Soft White paper, B2 size (71 × 51cm/27⁷⁄₈ × 19⁷⁄₈in).

Brien also produces calendars as promotional pieces, and, as he explains, 'because my planning and organising skills leave much to be desired.' They are printed on 200gsm Heritage paper, a robust, forgiving and wood-free paper well suited to the calendar's daily use.

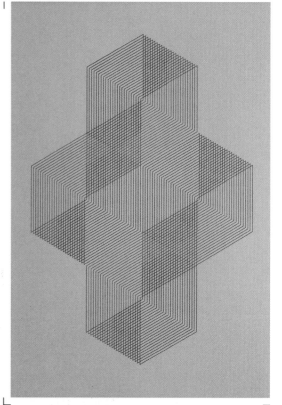

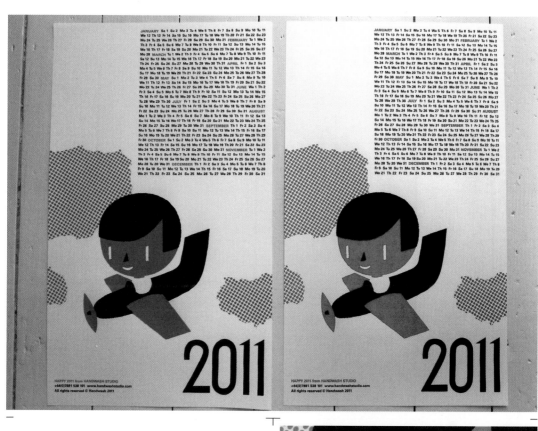

Todd Slater

Round Rock, Texas, USA

Todd Slater's inspiration for his *Ween* poster (shown right) came from Louis Wain's schizophrenic cat paintings. The posters were printed on white paper, which is only visible at the borders. 'I like to print full coverage with my inks as it gives the prints a really rich and layered look,' says Slater.

Slater's *Band of Horses* poster (below) was printed on black French paper with metallic gold and metallic copper inks. Each shape was placed individually into the design as if Slater was building his own kaleidoscope pattern. The printing was done by D&L Screenprinting in Seattle, USA.

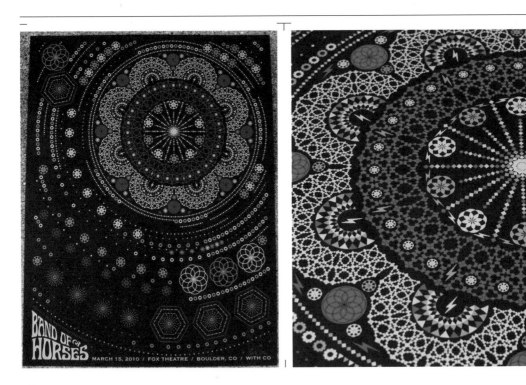

BAND OF HORSES MARCH 15, 2010 / FOX THEATRE / BOULDER, CO / WITH CO

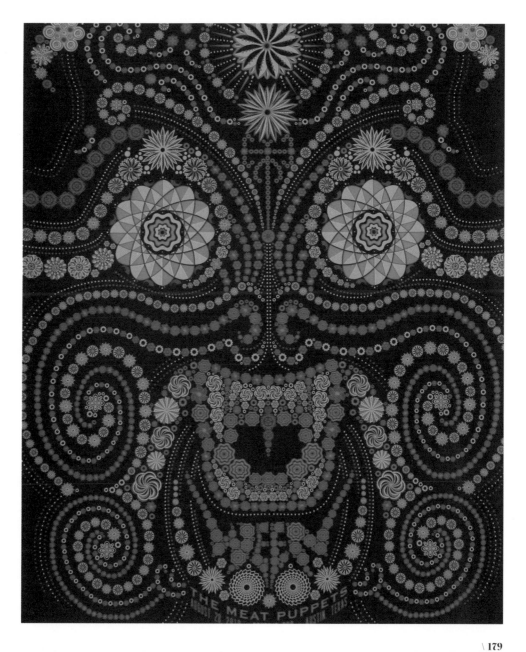

Deus Ex Machina
London, England, UK

Meta Book was a collaborative project, developed from artist Christina Mitrentse's design concept, created for an exhibition at the Lola Nikolaou Gallery, Thessaloniki, Greece. The book, when displayed wide open, is transformed into a sculptural object. The hardback covers and slipcase are made from recycled grey card and feature the artist's logo, hand printed in black ink. With a first edition of 10 (plus 5 artist's proofs), the piece measures 30 × 41 × 2.5cm (c. 12 × 16 × 1in) when in its slipcase. The book was printed by Jonas Ranson, with these photographs taken by Dominic Mifsud.

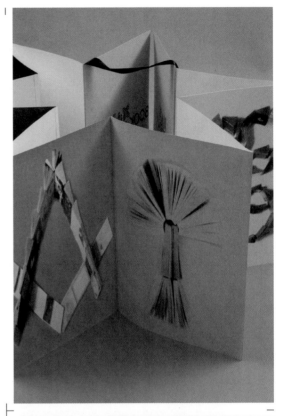

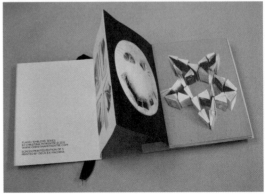

Jess Wilson

London, England, UK

With *Clinky Clanky*, illustrator Jess Wilson aimed to design the ultimate music-making machine – one that can create sounds for every emotion. 'What is the sound of fear?' ponders Wilson. 'Would the machine create a different sound for different people?' The four-colour poster is printed using TW Graphics inks, on Somerset 100-percent cotton paper. 'I wanted the piece to look like it was frothing at the top, so I used deckled paper,' explains Wilson. It was printed at Jealous Gallery, London.

Seripop
Montreal, Québec, Canada

Seripop is design duo Chloe Lum and
Yannick Desranleau. These images
show part of their series of large-scale
screenprinted paper installations.
Seripop's idea was to reinterpret the
screenprinted poster and its context,
aiming to exploit it in all its possible
physical forms.

'We used 50 different stencils to
print all the elements. The installation
required 1,000 sheets of paper to come
alive,' explains Desranleau. It took a
team of five people to put the installation
together over five weeks, wallpapering
all the floors and walls of the gallery,
and assembling about 300 paper bricks.
Rebecca Smeyne took these photos
at the Secret Project Robot Gallery
in Brooklyn, New York, USA.

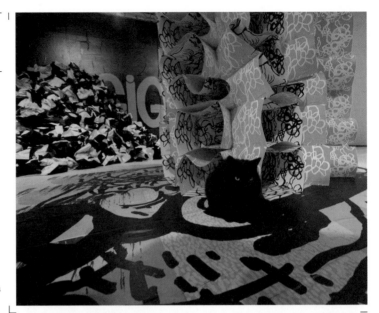

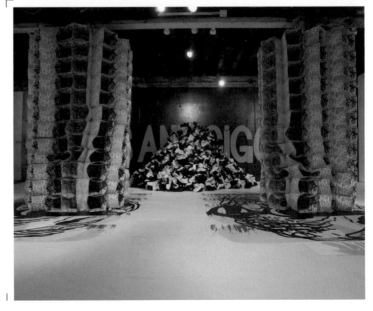

Resources

General resources

Etsy
Online marketplace for handmade and vintage crafts.
www.etsy.com

Gig Posters
Online art gallery showcasing the world's largest historical gig poster archive.
www.gigposters.com

OMG Posters
Blog about posters, prints and more.
www.omgposters.com

People of Print
Library of artists, collectives and studios who use the medium of print in their work.
www.peopleofprint.com

Silkscreen Tutorials
DIY screenprinting guide.
www.silkscreentutorials.com

Squeegeeville
Online community dedicated to the art and technology of screenprinting.
www.squeegeeville.com

Groups and workshops

American Poster Institute
Non-profit corporation dedicated to furthering public awareness and appreciation of the poster as an art form.
www.americanposterinstitute.com

East London Printmakers
This group of artists/printmakers provides an open-access facility for their studio, runs printmaking workshops and organises regular printmaking exhibitions and events.
www.eastlondonprintmakers.co.uk

Flatstock
The Flatstock poster show, presented by the American Poster Institute, is an ongoing series of exhibitions featuring the work of contemporary concert poster artists.
www.flatstock.wordpress.com

Idle Beats
Design and screenprinting studio based in Shanghai, China.
www.idlebeats.com

Lower East Side Printshop
Non-profit studio in New York City that helps contemporary artists create new artwork and advance their careers.
www.printshop.org

Poster Roast
Platform for artists to promote screenprinted gig posters.
www.posterroast.com

Print Club London
Open-access, water-based screen-printing studios open 24 hours, 365 days. Runs workshops, holds annual exhibitions and sells members' work.
www.printclublondon.com

Sparka Screenprinting Workshops
Beginner-level workshops run in eight US cities covering all aspects of the printing process, from building equipment, to design and printing.
www.sparkascreen.com

T-Shirt Forums
Online forum and newsgroup for discussing custom T-shirts, starting a business, screenprinting, embroidery, heat transfers, relabelling and sourcing hard-to-find materials.
www.t-shirtforums.com

West Yorkshire Print Workshop
Open-access printmaking facility that runs a regular programme of specialist printmaking courses for young people. It supports artists by providing printmaking facilities, affordable studio spaces and exhibition opportunities.
www.wypw.org

Supplies

Art 2 Screenprint.com
Online shop providing quality screen-printing equipment and supplies.
www.art2screenprint.com

ColorMaker Industries
Manufacturers of Permaset Fabric Printing inks. A complete range of colours, including metallics and fluorescents. All are water-based so equipment can be easily cleaned with water after use.
www.colormaker.com.au

Daler-Rowney
Manufacturers of System 3 acrylics and screenprinting media. System 3 acrylics are highly versatile, water-based acrylic colours with high-quality pigments at an economical price.
www.daler-rowney.com

French Paper Co.
Family owned for five generations, the French Paper Company is one of the smallest paper mills in America. Manufacturers of an extensive range of coloured papers and boards.
www.frenchpaper.com

JPP (John Purcell Paper)
Provides an extensive range of papers and boards.
www.johnpurcell.net

London Screen Service
Supplier and manufacturer of screens and screenprinting materials. Provides paper and textile screens as well as a screen re-stretching service. Also provides textile printing inks and media, along with other materials.
www.londonscreenservice.co.uk

Renaissance Graphic Arts, Inc.
Supplier of tools and products for the printmaking industry, including digital and traditional printing papers, drying racks and presses.
www.printmaking-materials.com

SilkScreeningSupplies.com
Offers low-cost screenprinting kits for start-ups, screenprinting equipment and screen presses.
www.silkscreeningsupplies.com

Speedball
Produce a complete line of block printing and screenprinting supplies, drawing pens, acrylic paints and watercolour palettes.
www.speedballart.com

TW Graphics
Online source for screenprinting supplies and inks.
www.twgraphics.com

Wicked Printing Stuff
Provides high-quality screenprinting equipment, supplies and services.
www.wickedprintingstuff.com

Contact Details

Arranged alphabetically by given name for individual names and by first word for company names

A. Micah Smith
www.myassociatecornelius.com

Above
www.goabove.com

Adam Turman
www.adamturman.com

AKA Corleone
www.akacorleone.com

Alison Tang
www.littleclouds.co.uk

Anna Lincoln
www.annalincoln.co.uk

Another Example
www.anotherexample.net

Ashkahn Studio + Co.
www.ashkahn.com

Atelier Deux-Mille
www.deux-mille.com

Bandito Design Co.
www.banditodesignco.com

Brainstorm Print + Design
www.wearebrainstorm.com

Craig Redman
www.craigredman.com

Cut-Out
www.cutoutshop.com

Damien Tran
www.damientran.com

Dan Stiles
www.danstiles.com

Design des Troy
www.design.des-troy.com

Deus Ex Machina
www.jonasranson.com

DKNG Studios
www.dkngstudios.com

DNML
www.dnml.org

Doe Eyed
www.doe-eyed.com

Douze Design Studio
www.douze.de

Egg Cup Soldier
www.etsy.com/shop/eggcupsoldier

Electric Company
www.etsy.com/shop/electricco

Ellie Curtis
www.elliecurtis.com

Fire Studio
www.firestudiodc.com

Gary Taxali
www.garytaxali.com

Graham Carter
www.graham-carter.co.uk

Greg Pizzoli
www.gregpizzoli.com

Gregory Gilbert-Lodge
www.gilbert-lodge.com

Handwash Studio
www.handwashstudio.com

Haniboi Co., Ltd.
www.haniboi.com

Happiness Brussels
www.happiness-brussels.com

Heather Lins Home
www.heatherlinshome.com

Heiko Windisch
www.heikowindisch.com

Hero Design Studio
www.heroandsound.com

House Industries
www.houseind.com

Iain Hector
www.iainhector.com

IdleBeats
www.idlebeats.com

If'n Books + Marks
www.ifnbooks.com

James Joyce
www.jamesjoyce.co.uk

Jamie Reed (HumanShapedRobot)
www.humanshapedrobot.com

Jasper Goodall
www.jaspergoodall.com

Jess Wilson
www.jesswilson.co.uk

Joe Wilson
www.joe-wilson.com

Kay Stanley
www.cutoutshop.com

Kid Acne
www.kidacne.com

Landland
www.landland.net

Le Dernier Cri
www.lederniercri.org

Luke Drozd
www.lukedrozd.com

Luke Whittaker
www.lukewhittaker.co.uk

Martin Ernsten
www.martinernstsen.com

Maya Hayuk
www.mayahayuk.com

Mikey Burton
www.mikeyburton.com

Mis Nopales
www.misnopales.com

Morning Breath
www.morningbreathinc.com

MouseSaw
www.mousesaw.com

Nick Agin
www.cargocollective.com/nickagin

Nini Sum
www.ninisum.com

Nobrow
www.nobrow.net

Ork Posters
www.orkposters.com

Patent Pending Industries
www.patentpendingindustries.com

Patswerk
www.patswerk.nl

Peter Stitson
www.peterstitson.com

Print Club London
www.printclublondon.com

Rob Ryan
www.misterrob.co.uk

Robin & Mould
www.robinandmould.blogspot.com

Rose Stallard
rose@printclublondon.com

Seb Lester
www.seblester.co.uk

Seripop
www.seripop.com

Shepard Fairey / Obey Giant Art Inc.
www.obeygiant.com

Snowblinded
www.snowblinded.com

Sonnenzimmer
www.sonnenzimmer.com

Steady Print Shop Co.
www.steadyprintshop.com

Studio MIKMIK
www.studiomikmik.co.uk

Susie Wright
www.suzyqandtheowls.co.uk

Tad Carpenter
www.tadcarpenter.com

The Comet Substance
www.cargocollective.com/
cometsubstance

The Decoder Ring Design Concern
www.thedecoderring.com

The Little Friends of Printmaking
www.thelittlefriendsofprintmaking.com

The Rise Up Haiti Project / Intrinzic
www.intrinzicinc.com

The Silent Giants
www.thesilentgiants.com

The Small Stakes
www.thesmallstakes.com

Todd Slater
www.toddslater.net

Tom Frost
www.tomfrostillustration.com

Tom Rowe / Tweed Tom
www.tweedtom.com

Transmission
www.thisistransmission.com

Two Guitars Art Cards
www.twoguitars.etsy.com

-V- Workshop
www.vworkshop.com

Vahalla Studios
www.vahallastudios.com

Vic Lee
www.viclee.co.uk

Wertzateria
www.wertzateria.com

Will Scobie
www.willscobie.co.uk

Zara Wood
www.zarawood.com

Zookimono
www.zookimono.com

Index

Acknowledgements

Writing and researching this book has been an amazing experience. The depth and breadth of fantastic work that is being created today using this most traditional method of printmaking has not only inspired me hugely, but also made me incredibly proud to call myself a screenprint practitioner.
I'd like to thank all the designers and studios around the world for their help and contributions, which have made this book so visually brilliant.

Thank-you also to all the team at RotoVision, to Stewart and Ivan, and Graham and Alice at Boxbird Gallery. A particularly big thanks goes to Dan Padavic and all at Vahalla Studios for writing the book's foreword.

This book is for Mum and Dad, for their continual support and belief.

About the Author

Caspar Williamson is a designer, printmaker, art director and author based in London, UK.

Having established his design studio, Flyingmachines, in 2007, Williamson has had the pleasure of exhibiting his screenprinted work alongside such prolific artists as Shepard Fairey, Airside, D*face, Pure Evil and Eine, amongst others.

His work has also been featured in leading design publications such as *Creative Review* and *Elle Décor*, and published by London's Nobrow Press, for which he received a D&AD awards listing in 2010.

Williamson is also one half of London screenprint collective Egg Cup Soldier.